FIAF DIGITAL PROJECTION GUIDE

TORKELL SÆTERVADET

FIAF DIGITAL PROJECTION GUIDE
© 2012 Torkell Sætervadet and The International Federation
of Film Archives (FIAF) – Brussels
ISBN: 9782960029628

English language consultant: Elaine Burrows
Graphic design: Lise Kihle Designstudio AS
Adoptions of illustrations: Skin Design AS, Oslo and
Lise Kihle Designstudio AS

Printed in Tallinn, Decmber 2012, by Printall.

The publication of this book would have been impossible
without the generous support from the following funding
sources and donors:

The Norwegian Film Institute:
Nina Refseth, CEO
Julie Ova, Executive director, audience department
Lise Gustavson, Head of film museum, exhibitions & editions

FIAF – Fédération Internationale des Archives du Film:
Christophe Dupin (Senior Administrator)
Antti Alanen and Jon Wengström (Past and current head of
Programming and Access to Collections Commission)

Le Giornate del Cinema Muto – La Cineteca del Friuli
Luca Giuliani

The author would like to thank the following individuals for
their input and contributions:

Alan Haigh, John F. Allen, Wolfgang Woehl, Nicola Mazzanti,
Dana Mackenzie, Sigurd Wik, Jan Eberholst Olsen, Geir
Friestad, Stefan Scholz, Mikko Kuutti and Dan Fuhlendorff.

CONTENTS

CHAPTER 1 **INTRODUCTION** **5**
CHAPTER 2 **WHAT IS D-CINEMA AND WHAT ARE THE ALTERNATIVES?** **9**
2.0 INTRODUCTION 9
2.1 DCI AND STANDARDS COMPLIANCE 9
2.2 THE DCI SPECIFICATION AND SMPTE D-CINEMA STANDARDS – KEY CHARACTERISTICS RELEVANT TO ARCHIVE CINEMAS 10
2.3 WHY DCI COMPLIANCE MATTERS TO AN ARCHIVE CINEMA 12
2.4 E-CINEMA AND HOME CINEMA 12
2.5 IS A LESS COSTLY NON-DCI SYSTEM AN ALTERNATIVE? 13

CHAPTER 3 **PIXEL – THE DIGITAL PICTURE ELEMENT** **17**
3.0 INTRODUCTION TO PIXELS 17
3.1 WHAT IS RESOLUTION? 17
3.2 WHAT RESOLUTION IS REQUIRED FOR D-CINEMA PROJECTION? 18
3.3 VISUAL ACUITY AND RESOLUTION REQUIREMENTS 19
3.4 HORIZONTAL VIEWING ANGLE AND RESOLUTION REQUIREMENTS 24
3.5 2K OR 4K? 26

CHAPTER 4 **THE DCP FILE FORMAT** **31**
4.0 INTRODUCTION 31
4.1 FRAME RATE 32
4.2 COLOUR SPACE 33
4.3 COLOUR RESOLUTION 34
4.4 IMAGE RESOLUTION 36
4.5 IMAGE CONTAINERS AND ASPECT RATIOS FOR D-CINEMA 37
4.6 IMAGE COMPRESSION 39
4.7 AUDIO 41
4.8 WRAPPING AND DISTRIBUTION FILES 44
4.9 NAMING OF DCPS 46
4.10 SECURITY AND KEYS 46
4.11 HARDWARE SECURITY 48
4.12 WATERMARKING 49

CHAPTER 5 **PROJECTION SYSTEMS** **51**
5.0 BASIC PROJECTOR TECHNOLOGY 51
5.1 LCD PROJECTORS 51
5.2 DLP PROJECTORS 53
5.3 LCOS AND SXRD 54
5.4 PROJECTOR LIGHT SOURCE 56

5.5 DCI AND PROJECTOR PERFORMANCE REQUIREMENTS 58
5.6 CHOOSING A PROJECTOR 59
5.7 DLP OR SXRD? 61
5.8 OTHER PROJECTOR CHARACTERISTICS RELEVANT TO FILM ARCHIVES 63
5.9 SERVER AND MEDIA BLOCK 64
5.10 CHOOSING A SERVER/MEDIA BLOCK 66
5.11 ARCHIVAL FRAME RATE SUPPORT 66
5.12 EQUIPMENT LIFETIME AND WARRANTY 70
5.13 PREPARING THE PROJECTION BOOTH 71

CHAPTER 6 **3-D SYSTEMS** **75**
6.0 INTRODUCTION TO STEREOSCOPY 75
6.1 POLARISATION AND 3-D 77
6.2 REAL-D 79
6.3 DEPTHQ 81
6.4 MASTERIMAGE 81
6.5 POLARISATION AND SCREENS 82
6.6 ACTIVE SHUTTER SYSTEMS AND XPAND 82
6.7 COLOUR TRIPLET SYSTEMS: DOLBY 3D 83
6.8 PANAVISION 3D – THE SHORT-LIVED FAVOURITE? 85
6.9 WHICH 3-D SYSTEM TO CHOOSE 85
6.10 DCPS IN 3-D 87
6.11 3-D AND INSUFFICIENT LIGHT LEVELS 88
6.12 EXCESSIVE LIGHT OUTPUT IN 2-D 90

CHAPTER 7 **SOUND FOR DIGITAL CINEMA** **93**
7.0 D-CINEMA AUDIO 93
7.1 EXTENDED SURROUND SYSTEMS 94
7.2 AURO-3D 95
7.3 IMM SOUND 97
7.4 DOLBY ATMOS 98
7.5 IOSONO 102
7.6 D-CINEMA SOUND PROCESSORS 103
7.7 CINEMA AUDIO REQUIREMENTS 106

CHAPTER 8 **D-CINEMA IN THE BOOTH** **109**
8.0 INTRODUCTION 109
8.1 PROJECTOR MACROS 110
8.2 DCP INGEST AND VALIDATION 111
8.3 PREPARING YOUR OWN DCP HARD DRIVE 112
8.4 ALTERNATIVE CONTENT 113
8.5 MAINTENANCE 114

REFERENCES AND SOURCES **116**
INDEX **119**

CHAPTER 1 **INTRODUCTION**

When *The Advanced Projection Manual* was published in 2006, its aim was to provide projectionists and cinema engineers with a practical guide to projection of classic films with modern equipment. While focusing on analogue film projection, the book also covered electronic and digital projection in detail.

Since then, however, the paradigm change from analogue film projection to digital cinema (D-cinema) has finally taken place. While film archives and cinémathèques still project photo-chemical film prints, the number of screenings where digital projection is required is increasing rapidly.

The Programming and Access to Collections Commission of FIAF (The International Federation of Film Archives) has encouraged me to publish a booklet where projection of digital and electronic images is covered in greater detail, while including the latest technological developments and their impact on archival projection. The result is the publication you are now reading, *FIAF Digital Projection Guide*.

The red thread of the text continues to be the aim of presenting films exactly the way they were intended to be presented – without any compromises with regard to picture, sound and appearance. Cinémathèques, film archives and film institutes have a particular responsibility to respect the integrity of the work of art that they are exhibiting, and the inevitable consequence is that the technical requirements will be pretty rigid. However, being fully aware of the restricted funds available to the type of cinemas in question, I have attempted to suggest

economical work-arounds wherever they can be applied without causing compromises which are disturbing to the audience.

Due to the rapid development of D-cinema technology, the products mentioned in this booklet are likely to become obsolete within a handful of years. Consequently, this publication is likely to require frequent updates.

Being initiated by FIAF, this booklet is particularly aimed at the technical staff of the FIAF member organisations such as national film archives, museums and institutes. However, the publication may be equally useful to others screening classic films, such as staff at educational organisations, independent repertory cinemas, and commercial cinemas with classic films on their programmes.

To receive the full benefit of this publication it is an advantage to have had professional training as a projectionist and/or cinema engineer. The technical level of the booklet requires at least basic knowledge about cinema technology and projection practices, and it is assumed that the readers are familiar with the content of my previous book, *The Advanced Projection Manual* (2006).

The Advanced Projection Manual was published jointly by FIAF and the Norwegian Film Institute in 2006.

CHAPTER 2 WHAT IS D-CINEMA AND WHAT ARE THE ALTERNATIVES?

2.0 INTRODUCTION

D-cinema is an abbreviation for digital cinema. As such, the term could be used to describe any cinema system which is digital, in contrast to a cinema system based on photo-chemical film (or analogue video tape, for that matter). In the APM (The Advanced Projection Manual, Sætervadet, Oslo/Brussels, 2006), the definition was a bit more concise: "D-cinema is the term used to describe a complete digital distribution and projection system able to produce a picture quality similar to 35mm film."

In this publication, however, we have chosen a more narrow definition of D-cinema: the term describes a cinema playback and projection system, which complies with the current SMPTE standards for digital cinema as well as being DCI-compliant.

2.1 DCI AND STANDARDS COMPLIANCE

DCI is an abbreviation for Digital Cinema Initiatives, LLC, a consortium established by the major Hollywood studios to develop a set of common requirements for D-cinema presentations. In addition to ensuring a minimum presentation standard with regard to picture quality and sound, ensuring interoperability between D-cinema systems from various hardware manufacturers has been crucial to the work of DCI. Another focal point for DCI has been to develop common security standards in the D-cinema file format and playback chain to avoid content theft.

Early digital cinema projectors were typically bolted onto lamphouse consoles normally used for 35mm film projection. Christie DCP-H (left) and Barco / Kinoton DP40 (right). (Christie and Barco.)

DCI circulated a number of draft specifications from 2004 onwards, and in July 2005 "Digital Cinema System Specification version 1.0" was released. Three years later, the current version 1.2 was made available, and this specification has been the basis for a number of D-cinema roll-outs world-wide.

The DCI specification is voluntary, and in theory all film distributors outside the DCI consortium could have chosen a completely different D-cinema playback format. However, the international importance of the Hollywood film industry means that the DCI specification has become a de-facto standard world-wide, at least for all cinemas wishing to project current Hollywood content.

While DCI is not a standardisation body, the Society of Motion Picture and Television Engineers (SMPTE) is and has to a large extent been standing on the shoulders of DCI during the development of the SMPTE standards for D-cinema, SMPTE ST 428 to ST 433.

2.2 THE DCI SPECIFICATION AND SMPTE D-CINEMA STANDARDS
 – KEY CHARACTERISTICS RELEVANT TO ARCHIVE CINEMAS

While D-cinema standards are still being refined and developed further, some common characteristics apply to current DCI-compliant D-cinema systems:

- The film is referred to as a DCP (Digital Cinema Package) which is projected and played from a playback server.
- The image is compressed using JPEG2000 intra-frame compression, and the frame rate was originally limited to 24 (2-D) or 48 fps (3-D).
- The sound is uncompressed at 24 bits and sampled either at 48 kHz or 96 kHz.
- The image and sound may be encrypted in their stored form to avoid content theft, but the encryption is optional.
- The playback server can be stand-alone (where the media block is integrated in the projector) or have a media block built in. If the latter, the media block outputs video signals to the projector (in the form of dual HD-SDI link-encrypted video signals).
- The signal path is partially encrypted to avoid content theft.
- The projector resolution is either 2k (2048 x 1080) or 4k (4096 x 2160). The actual image resolution will obviously depend on the aspect ratio of the cotent, as will the resolution of the capturing and post-production devices.
- In the projector, there is one light modulator for each primary colour (red, green and blue).
- The light modulator is currently either a DMD (Digital Micro-mirror Device) being a part of Texas Instruments' DLP (Digital Light Processing) system, or an SXRD chip (Silicon X-tal Reflective Display) from Sony. Other light modulators, such as GLV (Grating Light Valve) are under development but have so far not reached the D-cinema sphere.
- The projected image contrast is natively high and standardised to certain minimum values. No dynamic iris or other unpredictable contrast-enhancing devices are allowed.
- The light source is normally a xenon bulb to ensure a full range and compliant colour spectrum. Experimental systems may utilise lasers as a light source; however, all DCI-compliant projectors being sold to date use xenon lamps. An exception is Sony's new SXRD projector launched in 2012, which uses a cluster of Ultra High Pressure (UHP) lamps.
- The projector can fairly easily be calibrated with a colour meter (spectroradiometer), ensuring correct colours and light levels.

A D-cinema audio system has a minimum channel configuration of 5.1, but the DCP can contain as many as sixteen channels of audio. Certain proprietary audio coding techniques, such as Auro-3D, IOSONO or Dolby Atmos can increase the number of playback channels to 64 or more. However, these coding techniques are not a part of the open DCP format and require special processing equipment.

The number of channels for a particular film may be less than 5.1 (for instance single channel mono).

The Digital Cinema System Specification version 1.2 was released in 2008 and has provided the basis for a number of digital roll-outs world-wide.

2.3 WHY DCI COMPLIANCE MATTERS TO AN ARCHIVE CINEMA

Standards compliance is important for two reasons. First, it provides a certain level of insurance that the picture and sound quality is predictable and in line with the film-makers' intentions. An audience present at a D-cinema screening can be reasonably sure that the image and sound experience is very close to the experience on the premiere night, provided that the system complies to the DCI specification and is correctly calibrated.

Secondly, by being DCI-compliant, the D-cinema system will be accepted by the major copyright holders, and the cinema will be regarded as a legitimate venue for their films. Without DCI compliance, the cinema will simply not be allowed to play the majority of feature films on the market. This goes for films in current cinema distribution as well as a number of restored film classics owned and/or managed by the Hollywood majors.

2.4 E-CINEMA AND HOME CINEMA

To distinguish between D-cinema and other forms of digital film projection, the terms electronic cinema (E-cinema) and home cinema will also be used in this publication. E-cinema refers to any commercial grade non-DCI-compliant projection and playback platform. It will typically consist of a computer, tape based players and a BluRay or DVD player, in combination with a digital projector intended for professional use.

E-cinema is typically accompanied by two-channel stereo or 5.1 channel sound.

E-cinema will normally be of a lower quality than D-cinema, but there are some few E-cinema systems out there with better performance in some respects than most D-cinema systems, for example some ultra-high resolution systems.

The main problem with E-cinema systems is that they are not standardised and normally not accepted for D-cinema screenings. It is of little help to have a projection system, which is either cheaper or better than a D-cinema system, if you can't get access to most motion picture content.

Home cinema describes a projection system for domestic use, which mimics the performance of a D-cinema system. In some rare cases and certain respects, high-end home cinema can outperform D-cinema. Generally it is true to say that D-cinema will be vastly superior, due to the high level DCP format and the high quality projectors associated with D-cinema standards. Home cinema systems are generally not standardised, and unpredictable technologies inside the projector are often used to "enhance" the image experience. Such technologies include the dynamic iris, a system that uses a variable lens aperture to increase or reduce the light output depending on the image content of a scene. While this tech-

For 19,400 euros you can have a 4k home cinema projector with 2.000 ANSI-Lumens light output, Sony VPL-VW1000ES. (Sony)

nology will increase the perceived image contrast from one scene to another, the more important intra-frame contrast (contrast within a frame) stays the same. Also, there are few ways to ensure that the viewing experience is consistent across auditoria. Another drawback is that these systems are fairly hard to calibrate to industry standards. (They are, on the contrary, frighteningly easy to calibrate to the viewer's taste.)

The Panasonic DZ12000 projector is a good example of a high-end projector suitable for E-cinema. With a three-chip DLP light engine and full HD, the projector is capable of reproducing very high quality images. The only problem is the cost: With a street price of more than 63.000 euros (source: Projector Central), the projector is actually more expensive than a D-cinema projector. (Panasonic)

2.5 IS A LESS COSTLY NON-DCI SYSTEM AN ALTERNATIVE?

There are low cost ways to do high quality digital projection, particularly if the screen size is fairly small (a three-to-four metre screen width or less in the Cinema Scope format). The two most important questions one should ask oneself before choosing against D-cinema are:

1) Will my content providers accept the projection/playback system?
2) What do I want to accomplish with my cinema?

With regard to question number one, one may be fine with an E-cinema or home cinema system as long as there are no plans to screen films from content providers who are only willing to accept DCP projection of their films. While many content providers would happily lend out a DigiBeta or HDCAM tape in the past, an increasing number of them will only accept DCP distribution. As cinemas are digitised across the globe, this trend is becoming more and more prevalent by the day. Content protection, cost and presentation consistency are the three main driving forces. Even some film archives will only distribute certain content as DCPs these days. Even in case your cinema can currently access a wide range of digital content legally in other formats than DCPs, going for anything but D-cinema carries the risk that your cinema will lose access to content in the near future once policies change.

Low-cost home cinema projectors provide "value for money", but they tend to be equipped with LCD panels or a single-chip DLP panel. This particular projector (Optoma HD33, single-chip DLP) has a street price of around 1,100 euros. The light output is 1,800 ANSI-Lumens, sufficient for a 2-D image of approx 4 to 4,5 meters in width (depending on screen gain). (Optoma)

If, however, you are only going to show your own archive content, you may obviously choose any other projection platform and stay with it as long as you like, providing you have made a conscious choice about image and sound quality. Also, if your content provider allows you to use domestic BluRay disks for projection to a larger audience – and if you are confident that they will stick to this policy – you may be fine with an approach other than D-cinema.

The second question is of a more philosophical nature and taps into the core of the idea of cinémathèques and archival cinemas as such. Today, people are surrounded by high quality moving images. As these become the norm rather than the exception, the eyes of the audience are becoming more and more critical. While one could easily project a hammered and faded 16mm film print of a rare title at a cinémathèque some twenty years ago, today's audience will complain – or, worse, never return to the cinema.

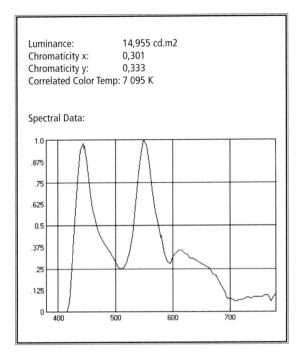

Luminance: 14,955 cd.m2
Chromaticity x: 0,301
Chromaticity y: 0,333
Correlated Color Temp: 7 095 K

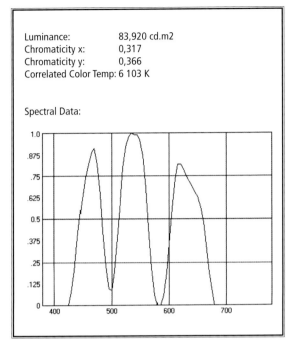

Luminance: 83,920 cd.m2
Chromaticity x: 0,317
Chromaticity y: 0,366
Correlated Color Temp: 6 103 K

The raw spectral response of a typical non-xenon projector (left, Infocus 777) compared to a projector with a xenon light source (right, Sony SRX-R110). In both cases out-of-the-box "reference white" was projected on the screen.

As can be seen, the light output of the projector without a xenon lamp is non-linear with a rather limited response in the red area (600nm to 700nm wavelenght). Calibrating the light by cutting the peaks in the blue and green areas of the Infocus 777 will dramatically reduce the light output.

Thanks to low cost BluRay, cinephiles have access to extremely high quality versions of their favourite film classics. They can watch these films in the comfort of their own homes thanks to high-performance home cinema equipment.

Those less concerned about quality but more focused on selection and choice, can download or stream an incredible number of films online.

With this backdrop, why should the audience accept a sub-standard experience at national museums celebrating the film heritage (as most film archives are supposed to be)? If the cinémathèques can't provide a reasonable guarantee that the audience is seeing something as close as possible to the original film experience, why should those cinémathèques even exist? Hardly because they are generally better at putting films into context than a large number of online services, one would imagine.

It is this author's opinion that a cinémathèque should provide a guarantee for the best possible film experience, just as a Michelin starred restaurant gives one reasonable hope for an unforgettable meal.

Having said this, there are circumstances where a projection system outside the

D-cinema family makes sense, for instance in smaller research preview theatres with limited screen sizes (up to three or four metres in width).

The reason why size matters is that the smaller screens can be successfully equipped with high-end home cinema projectors, which are the closest to match the image quality of a D-cinema system at a substantially lower cost.

With regard to larger screens, one would either have to accept a lower image quality (most notably linked to colour reproduction, resolution and screen illumination) or choose equipment that is actually more expensive than a D-cinema system. D-cinema equipment has come down dramatically in price recently, and it will soon be possible to buy brand-new D-cinema systems consisting of a server and projector for as little as €30,000. The €50,000 mark is already within reach. Many cinemas will therefore be surprised to learn that going outside the D-cinema range is not a strategy guaranteed to cut costs.

Regardless of screen size, the following criteria should be absolute for a high-quality E-cinema/home cinema system:

- One light modulator per colour channel (three-chip projector)
- Minimum native resolution of 1920 x 1080 pixels
- Minimum contrast ratio of 2000:1 (inter frame contrast)
- HDCP-compatible DVI-D/HDMI input
- Other inputs should include: secondary DVI-D/HDMI, RGBHV analogue video, YPbPr component analogue video, composite video – without these inputs, an external scaler/processor may be required
- Colour and illumination calibration features
- Projected colour range complying with ITU recommendation 709

Desirable features include:

- The projector should be equipped with a xenon light source to ensure wide-range colour projection
- It should be possible to switch off on-screen-display messages, also when input sources are changed
- The projector should be equipped with lens presets (zoom, focus, lens shift), particularly if the cinema has a fixed image height

CHAPTER 3 PIXEL – THE DIGITAL PICTURE ELEMENT

3.0 INTRODUCTION TO PIXELS

While the main building block of photo-chemical film is silver halide grain with colour couplers, a digital image consists of a number of picture elements referred to as pixels. Each pixel represents a space-specific sample of the illuminance and colour of an image. When added together, the pixels form a uniform image, and if the image consists of a sufficient number of pixels for a specific image size and viewing distance, the pixels cannot be seen by the naked eye.

Both during capture and display/projection of a digital image, the pixels are in a fixed position, unlike film grain which is entirely random. The fixed position of the pixels makes them fairly easy to spot if they are large compared to the viewing distance, and they can cause visible artefacts such as jaggy edges and moiré.

3.1 WHAT IS RESOLUTION?

We can define resolution as the number of picture elements for each colour utilised to form an image. The resulting number will be in the millions of pixels range, abbreviated Mpx for mega-pixels. For instance, D-cinema in the 2k format contains approximately two million pixels or 2Mpx. The 4k format contains four times as many pixels, in other words 8Mpx. Some camera and projection manufacturers refer to the pixels in total rather than pixels per colour, creating the impression that a 2Mpx image is a 6Mpx one. In this publication, we will always refer to the resolution as the number of pixels per colour.

The image building block of the photochemical film emulsion consists of random silver halide grain. (Harman Technology, Ltd, previously known as ILFORD.)

In contrast, digital projection is achieved with a fixed pixel grid, here a DMD chip, where one single mirror has been removed to reveal the hinge mechanism of the device. (Texas Instruments)

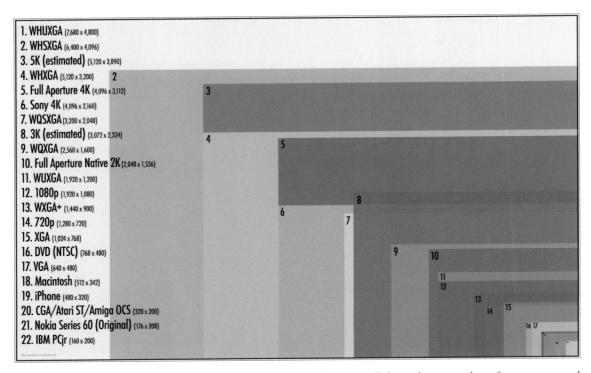

1. WHUXGA (7,680 x 4,800)
2. WHSXGA (6,400 x 4,096)
3. 5K (estimated) (5,120 x 3,890)
4. WHXGA (5,120 x 3,200)
5. Full Aperture 4K (4,096 x 3,112)
6. Sony 4K (4,096 x 2,160)
7. WQSXGA (3,200 x 2,048)
8. 3K (estimated) (3,072 x 2,334)
9. WQXGA (2,560 x 1,600)
10. Full Aperture Native 2K (2,048 x 1,536)
11. WUXGA (1,920 x 1,200)
12. 1080p (1,920 x 1,080)
13. WXGA+ (1,440 x 900)
14. 720p (1,280 x 720)
15. XGA (1,024 x 768)
16. DVD (NTSC) (768 x 480)
17. VGA (640 x 480)
18. Macintosh (512 x 342)
19. iPhone (480 x 320)
20. CGA/Atari ST/Amiga OCS (320 x 200)
21. Nokia Series 60 (Original) (176 x 208)
22. IBM PCjr (160 x 200)

Resolution is an expression of how many pixels that are used to form an image in the horizontal and the vertical domains. Computer monitors, phone displays and projection may utilise a number of various resolutions. Illustration: gadgets.boingboing.net

The image quality of a digital image will depend on a number of parameters, and while high resolution alone does not guarantee a high quality image, the resolution is a very important factor. However, it is crucial to distinguish between the resolution requirements for capture/photography/post-production and those for display/projection. While a number of different resolutions are relevant in the production stage of a film, it is actually the cinema design which governs the resolution requirements for projection.

3.2 WHAT RESOLUTION IS REQUIRED FOR D-CINEMA PROJECTION?

Ideally, the projector resolution should be sufficiently high that projector pixels cannot be seen by the audience anywhere in the seating area of the auditorium. Opponents of this ideal may claim that photo-chemical film never had such a high resolution (grain could more often than not be seen), while others point out that a number of films will be originated on much lower resolution than such an ideal would indicate.

Following the philosophy of this publication, however, even a low-resolution film should not suffer visible projector pixels added to the pixels or grain used to form the original image. A cinema ought to be a neutral and transparent window, which does not add or subtract anything from the original artefact

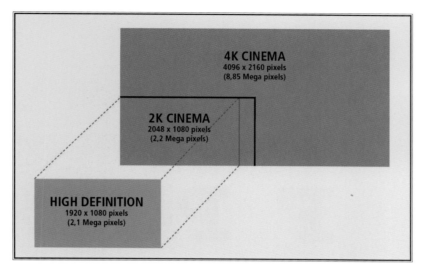

4K CINEMA
4096 x 2160 pixels
(8,85 Mega pixels)

2K CINEMA
2048 x 1080 pixels
(2,2 Mega pixels)

HIGH DEFINITION
1920 x 1080 pixels
(2,1 Mega pixels)

Left: The D-cinema specification consists of two resolutions, 2k and 4k. 2k is almost identical to HD, whereas 4k is four times larger. (Sony)

Above: Using a sufficient number of pixels compared to the viewing distance ensures a seamless image. The resolution of the image to the right is four times that of the left. Illustration: Apple, Inc ("About High resolution for OS-X", Mac Developer Library, 2010.)

being projected. Only by adhering to this rule can the integrity of each and every original image be kept, regardless of whether the resolution of the original film is low, medium or high.

3.3 VISUAL ACUITY AND RESOLUTION REQUIREMENTS

The resolution required to meet the strict criterion of "no visible pixels" will depend on two factors:

1) The acuity of human vision
2) How many degrees of the horizontal viewing angle of patrons in the front row the screen width will cover.

Obviously, the acuity of human vision varies from person to person, but a general rule of thumb is the normalised Snellen fraction of 20/20 vision, implying that a human with normal vision at twenty feet distance can distinguish between two adjacent points forming an angle of an arcminute – one 60th of a degree. Some people have poorer vision, even when corrected with glasses or contact lenses, for instance down to one 45th of a degree. However, it is in fact more common to find humans with better vision, up to one 75th of a degree. Consequently, we will assume an arcminute as the figure for human visual acuity in this publication.

In the cinema industry, some projector manufacturers, which were late to market with high-resolution 4k projectors, have argued that the above assumption of human acuity does not apply to digital projection in cinemas, since luminance levels are low compared to light levels in clinics where eye tests take place. For instance, Alan Koebel writing for the DLP projector manufacturer, Christie,

Line	Acuity
1	20/200
2	20/100
3	20/70
4	20/50
5	20/40
6	20/30
7	20/25
8	20/20
9	
10	
11	

A typical Snellen chart, originally developed by the Dutch ophthalmologist Herman Snellen in 1862 to estimate visual acuity. When printed out at the correct size, the E on line one will be 88.7 mm (3.5 inches) tall, and when viewed at a distance of 20 ft (=6.096 metres), you can estimate your eyesight based on the smallest line you can read. Line number eight represents 20/20 vision (acuity of one arcminue). Illustration: Jeff Dahl, Creative Commons.

argues that the Snellen test chart for human vision requires a minimum luminance of the white background of 120 candelas per square metre (cd/m^2) compared to the D-cinema standard of $48cd/m^2$, and that the lower light condition causes a dilation of the pupil from 3mm to around 4–6mm. Koebel argues further that this increase in lens aperture causes roughly a 30% drop in visual acuity, equivalent to human acuity of 42 instead of sixty pixels per degree. (Digital cinema projection: choosing the right technology, Alen Koebel, 2011).

Koebel's argument does not agree with current international standards and scientific research, however. First of all, the minimum test chart luminance is highly variable across countries, and the minimum luminance accepted for eye tests is significantly lower than 120cd/m2. The international visual acuity measurement standard specifies that it is desirable if test chart luminance is not less than $80cd/m^2$ for clinical purposes (The Visual Acuity Measurement Standard, ICO, 1984).

While $80cd/m^2$ is obviously higher than the $48cd/m^2$ required for D-cinema, in cinemas we are still in what is considered normal light levels as long as we are operating at luminance levels between one and 106 cd/m^2. All the way down to $3cd/m^2$, the human vision is photopic, i.e. dominated by cone cells, achieving good visual acuity and color discrimination. (Scotopic vs. Photopic, Bill Schupple, LED Industries).

Indeed, for one hundred per cent contrast (black symbols against a white background), the acuity remains constant from 10cd/m2 and upwards. (Handbook of Optics: Visual Acuity and Hyperacuity, Gerald Westheimer, Berkeley, 2010.)

Furthermore, it is not correct to assume that 120cd/m2 would lead to a pupil size of 3mm while $48cd/m^2$ and lower would lead to a pupil size of 4–6mm. In fact, to what degree the pupils actually dilate as light levels drop varies greatly, most importantly with age. When exposed to $9cd/m^2$ of luminance, the diameter of the human pupil can vary as much as between 3mm and 9mm – even though the visual acuity is entirely normal at Snellen 20/20 in all these cases. Mean values indicate that a 40-year-old individual will, on average, have a pupil diameter of 5.5mm at $220cd/m^2$, 6mm at $44cd/m^2$ and 6.8mm at $9cd/m^2$. Median pupil diameters as low as 3mm only occur if one exposes test subjects to luminance levels of as much as 4400cd/m², and then, on average, only the oldest subjects will reach 3mm in diameter. (Factors Affecting Light-Adapted Pupil Size in Normal Human Subjects, Barry Winn, David Whitaker, David B. Elliott, and Nicholas J. Phillips, 1994.)

Most importantly, the argument about the increasing pupil size and the resulting loss of acuity is imprecise, if not incorrect. In fact, researchers at the Optical Laboratory at the University of Argentina found in 2004 that correlation

White papers on resolution from Arri, Barco, Christie and Sony present different views on projection resolution. Sony and Arri, both early adopters of 4k resolution, argue that the audience can indeed see the difference between 2k and 4k. Christie and Barco, both late to market with 4k technology, downplay the role of high resolution.

between pupil size and visual acuity is rather limited. The effect of a dilating pupil on visual acuity varies slightly between age groups, between individuals, and also between the two eyes of a single individual. Surprisingly, it is more likely that acuity improves as the pupil dilates among young people, than that acuity decreases with a dilating pupil among adults. Overall, visual acuity is claimed to be pretty constant as the pupil dilates from a minimum of around 3mm to a maximum of approximately 8mm. (Correlation between visual acuity and pupil size, Silvia A. Comastri, Rodolfo M. Echarri and T. Pfortner, Proc. SPIE 5622, 1341, 2004.)

This finding is surprising and counter-intuitive: we know from optical lens theory that a large aperture (f-stop) is associated with more lens aberrations. However, small apertures have the disadvantage of more diffraction. According to Westheimer, acuity will suffer first when the pupil size is outside the range of 2–6mm. (Handbook of Optics: Visual Acuity and Hyperacuity, Gerald Westheimer, Berkeley, 2010.)

Another point raised by Alan Koebel in his defence of 2k projection, is that some studies have suggested that normal visual acuity could be as low as 44 pixels per degree – which, with Koebel's reasoning about light levels and pupil size, indicates that 32 pixels per degree is sufficient in a darkened theatre.

This type of argument raises concerns about equipment manufacturers' use of so-called "white papers" to give their marketing strategy a scientific touch, keeping in mind that they may be tempted to cherry-pick research and findings supporting their products rather than providing complete information about recent research explaining the bigger picture.

To return to Koebel's argument, as mentioned above, it is correct that a number of patrons have visual acuity in the range of one 45th of a degree instead of the normalised arcminute. However, it is also true that a number of people have sig-

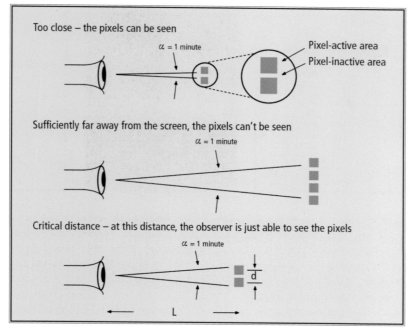

Leftt: A person with normal eyesight is able to see the pixels when the angle from the eye to two adjacent pixels subtends one arcminute.

Above: A fully dilated pupil. (Grendel Khan and Lady Byron / Wikimedia Commons)

nificantly better vision, at one 75^{th} of a degree or more. In fact, statistics from the US indicate that across all ages from eighteen to 79, there are more people with acuity of one 75^{th} of a degree (24.7%) than people with normal vision (22.6%). Those with acuity of as little as one 45^{th} of a degree amount to only 20.3% of the population. Strikingly, these figures apply to uncorrected or unaided vision. When corrected, as much as one third of the population has better than normal vision, and another third has normal vision. (Monocular-Binocular Visual Acuity of Adults, National Health Statistics, US, 1968).

It is also a fact that the complex human visual system can experience hyper-acuity, yielding resolution beyond what seems to be reasonable to expect based on the optical system of the eye alone.

A final argument often encountered in the defence of 2k, is that the acuity of human vision for moving images is much lower than for still images. While movement does matter for the perception of detail, the argument makes little sense, other than business sense, since a film normally contains a number of still images – and large still areas within a moving image, for that matter.

The fierce battle between the DLP projector manufacturers and Sony has lead to the release of white papers from Christie, Barco and Sony, and they should all be read critically, bearing in mind their commercial agenda.

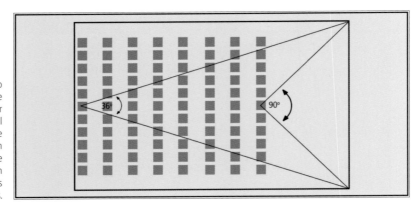

Modern cinema design is supposed to follow best practices, and some of these guidelines are regarded as mandatory for THX approval. The maximum horizontal viewing angle coverage is supposed to be 90° on the front row, while the minimum horizontal viewing angle coverage on the rear row should ideally be no less than 36°. Inevitably, this framework governs resolution requirements in cinemas.

3.4 HORIZONTAL VIEWING ANGLE AND RESOLUTION REQUIREMENTS

A misconception typically advanced by projector manufacturers is that the nominal screen size is the only relevant parameter to the resolution requirement of a D-cinema system. For example, one will often hear claims that 4k resolution is only required if the screen width is ten metres or more. (4k resolution: more than meets the eye, Bert/Marescaux, Barco, 2011)

This is incorrect, as we will understand from the concept of human visual acuity. What matters is only the relative screen size, given by the relationship between the nominal screen size and the viewing distance. For any single cinema, we need to know how many degrees of the horizontal viewing angle the screen width occupies. Obviously, the most critical row will be the front row.

Since most modern cinemas are (or should be) designed to SMPTE Engineering Guideline EG 18-1994 and THX certification criteria, the horizontal viewing angles are actually rather consistent and predictable, at least so in many markets. From the front row, the screen width in the widest format (typically 2.39:1 or 1.85:1) will normally occupy 90° of the horizontal viewing angle. At the rear, the THX requirement states that 36° is the design criterion (while 26° is the smallest allowable). In short, the resolution should be sufficiently high to make the pixels appear invisible at a horizontal viewing angle of 36° to 90°.

To simplify the maths, we can assume that we project on a sphere rather than a flat or slightly curved screen. If we do so, we just multiply 36° and 90° by 60, since we assume that human visual acuity is one 60th of a degree and we consequently are able to resolve sixty pixels per degree. To satisfy the front row, we then need 5,400 pixels across the screen, while the rear row will be satisfied with 2,160 pixels. In the sweet spot of the auditorium, i.e. the preferred position in a cinema for reference and mastering purposes, the viewing angle may be around 50° where 3,000 pixels are required.

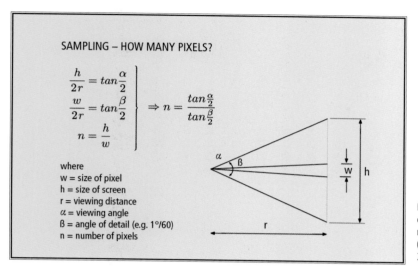

SAMPLING – HOW MANY PIXELS?

$$\frac{h}{2r} = tan\frac{\alpha}{2}$$
$$\frac{w}{2r} = tan\frac{\beta}{2} \Bigg\} \Rightarrow n = \frac{tan\frac{\alpha}{2}}{tan\frac{\beta}{2}}$$
$$n = \frac{h}{w}$$

where
w = size of pixel
h = size of screen
r = viewing distance
α = viewing angle
β = angle of detail (e.g. 1°/60)
n = number of pixels

How many pixels are required? This calculation shows how to establish the resolution requirements in cinemas. (After Mikko Kuutti, The Pixel, Helsinki 2007.)

Since the 4k format has 4,096 pixels across and the 2k format 2,048 pixels, one can see that the 4k format is almost good enough for the front row, whereas the 2k format is barely OK for the rear row of a modern and well-designed cinema. It does not matter if the screen is three metres or thirty metres across, as long as the 90° front-row rule and 36° rear-row rule have been followed in the design of the cinema.

However, this is a coarse approximation, since we are not projecting onto a sphere and since the patrons all have different positions in relation to the screen centre. The resolution requirement is even higher if one takes these facts into account. This is why:

Imagine a cinema where the screen is a sphere and where there is only one chair – positioned in the centre of the sphere. Given that the projection optics have been designed to yield square and evenly sized pixels on such a screen, the rule above would apply – and 5,400 pixels across would suffice when the horizontal viewing angle coverage is 90° (90 x 60 pixels).

However, in a cinema, the screen is flat or very slightly curved. Imagine that you convert the screen slowly from a sphere to a flat surface. The screen surface covering 90° of your horizontal viewing angle will travel further and further away from your own position – for all areas other than the single point of the screen, which is perpendicular to your own position. The arcminute acuity rule would mean that the 5,400 pixels will travel further and further apart as the screen moves towards becoming a flat surface – except for the point on the screen exactly level with your own line of sight. At your position, this does not matter since the

human visual acuity 1°/60	2.39	horiz.px 1.85	1.37	vert. px 1
36° (back)	2234	1729	1281	935
52° (middle)	3353	2596	1922	1403
90° (front)	6875	5322	3941	2877
human visual acuity 1°/75	2.39	horiz.px 1.85	1.37	vert. px 1
36° (back)	2792	2162	1601	1168
52° (middle)	4192	2421	1793	1754
90° (front)	8594	6653	4926	3596

The horizontal and vertical resolution requirement on various rows in the cinema as a function of eyesight and image format, assuming a fixed image height. Not even 4k is sufficient according to these calculations. (After Mikko Kuutti, The Pixel, Helsinki 2007.)

pixels aren't moving further away than the longer viewing distance compensates for, but for any other person on the same row, the pixels will start showing up due to their increased separation.

Projection systems are required to have constant resolution across the screen, hence the pixel separation of the most critical viewing point will govern the pixel distance anywhere on the entire screen.

Taking this into account, one theoretically needs 6,875 pixels across the screen to satisfy the front row, 3,353 for the middle row of the auditorium (at 52°) and 2,234 pixels for the rear row. (Kuutti, The Pixel, 2007).

3.5 2K OR 4K?

When taking on board the above figures, one may assume that current D-cinema standards of 2k and 4k are inadequate. From a pragmatic viewpoint, this is obviously not the case. Both projection formats have the power to impress an audience used to sub-standard presentation (which was unfortunately all too common in the days of 35mm film projection).

The numbers above do indicate, though, that the 4k format is much closer to the ideal cinema than 2k is. The author's empirical evidence shows the same: with 2k projection, a person with normal eyesight is very likely to see the pixels at any location in the cinema except perhaps for the rear couple of rows. To what extent the pixels will be visible depends on image content, but images with high contrast edges are the most revealing. With 4k, no reports of visible pixels have ever been noted in connection with today's cinema design.

Blind tests conducted for average audiences confirm the same finding (*Does 4k really make a difference?*, Sony, 2009).

The 2k or 4k resolution debate unfortunately became obscured by the fact that only one projection manufacturer (Sony) was initially capable of producing a 4k projector. The initial lack of 4k ability for the three brands using the Texas Instrument's DLP technology (Christie, NEC and Barco) led to a heated debate, where the 2k camp listed a number of reasons not to look at resolution when choosing a D-cinema projector. Even after the release of 4k DLP projectors, DLP manufacturers still tend to keep down-playing the role of resolution, presumably to keep up the demand for their dominant 2k projectors. (4k resolution: more than meets the eye, Bert/Marescaux, Barco, 2011).

Below are typical arguments against 4k, along with their counter-arguments:

- **The 4k benefit is only visible from the front couple of rows.** As we have seen above, and as blind tests have proven, this is not correct. It is actually only the rear couple of rows which will be fully satisfied by 2k.
- **The resolution requirement of one arcminute only applies to still images.** Perhaps so, but as pointed out above, a large part of any film image is occupied by still imagery, of which the critical spectator enjoys being able to see the detail. This applies even though the moving part of an image is what naturally attracts the initial glance.
- **The resolution requirement of one arcminute only applies to the very centre of the human field of vision.** This is correct, but a spectator will constantly change the centre of attention depending on his or her own preferences and curiosities.
- **4k is only required for big screens, from ten metres wide and above.** This is entirely incorrect. As we have seen, it is the relative, not the nominal, screen size, which matters.
- **The resolution alone does not define the quality of an image.** This is correct – when choosing a projector, a number of other parameters need to be taken into account, such as pixel density on the image chip, the extent of the dark area around each pixel, image contrast, colour consistency, hardware quality etc. As when choosing most other equipment, there is always a trade-off to be made. Since both Sony and the DLP camp are now able to provide 4k projection, one can actually settle for the optimum resolution first – and then afterwards decide on the preferred projector based on the other trade-offs and preferences.
- **Human visual acuity numbers do not apply to cinema projection due to low light levels.** As explained above, this is not correct. At full contrast and 48cd/m² screen luminance, the eye is operating in the normal acuity range – photopic vision. Scenes have to be very dark (peak light levels less than 10cd/m²) before

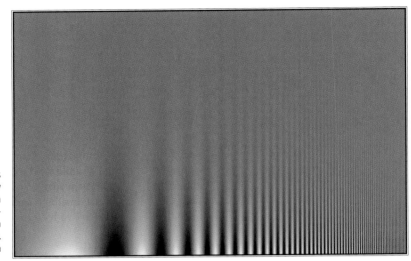

The chart illustrates contrast versus frequency (i.e. resolution) and shows how high contrast is required for the human eye to perceive high resolution. Consequently, not only the projector resolution matters, but also the contrast.
Illustration: Izumu Ohzawa

visual acuity drops under the normal level. Stereoscopic projection may in some cases operate at such low light levels (3.5 foot-Lamberts or 12cd/m² and lower) that visual acuity suffers in many scenes – one of many reasons why 3-D film projection often has a disappointing appearance.

- **There are no 4k films.** While a vast majority of DCPs are in 2k resolution, a number of 4k films are coming through. The number of titles is increasing, and post-production increasingly takes place in 4k. The most ambitious film archives have already started to do all their scans in 4k for both access and digital preservation purposes, making it particularly relevant for an archive cinema to go 4k. Also, the domestic market is about to move slowly from HD to 4k, with 4k BluRay and 4k home projectors now being available.

- **High frame rate (HFR) is more important than high resolution.** For the film heritage, this is certainly not the case, as 99.99% of all films are running at 24 or 25fps. A film archive is more likely to enjoy 4k projection of 4k archival scans than 2k HFR projection of 3-D blockbusters. However, it is possible to have one's cake and eat it: most projectors today can project 60fps (either out of the box or after an upgrade), and while HFR above 60fps is in the pipeline – and will be very useful in combination with 3-D – it is possible to have both HFR and 4k with today's selection of projectors.

Having said that, the resolution of the projector chip does not reveal the entire truth about the projected image resolution. The quality of the optical system in the projector (expressed as the modulation transfer function, MTF) will inevitably affect the projected resolution. Projection lenses may be a limiting factor in some cases, particularly where 2k systems with less capable lenses are upgraded to 4k.

Nevertheless, the recommendation of this publication is clear: 4k projection is by far the preferred platform, and 4k will provide the best basis for a "future proof" set-up, to the extent that something like that exists.

Once your film archive starts scanning at 4k, you will need a 4k projector to do a proper check of the scan. What's perhaps a bit more expensive today may prove cheapest a couple of years down the line.

CHAPTER 4 **THE DCP FILE FORMAT**

4.0 INTRODUCTION

When the DCI specification was created, one of the goals was to create an entirely open format, in order to prevent a format war. Competing proprietary formats have bugged the film industry many times before – as early as when the Lumière 35mm system with one perforation per frame was competing with Edison's 1 3/8" system with four perforations per frame. The fierce war between Sony's Betamax format and JVC's VHS format, which took place when consumer video appeared in the 1980s, is presumably still in many studio executives' memory. In more recent years, the format wars between SDDS, DTS and Dolby Digital in the cinema domain, and between HD-DVD and BluRay in the home theatre sphere, have shown how proprietary formats and fight over formats tend to delay the introduction of new technology. The huge benefit of the universal 35mm film standard, which has been in place with some adaptations since 1909, was something the film studios were eager to keep as they were moving towards D-cinema.

DCI brought together some of the leading engineers and experts in projection and digital imaging technology along with representatives from film distributors when designing their specification. Systematically and meticulously, the experts put together a rather strict specification, which was designed to be rugged and as future proof as possible. However, designing a system, based on a number of ideals, from the ground up, is contrary to how other formats have appeared. In fact, at the time that the DCI specification was put together, there was no hardware available to show films which would actually conform one hundred per cent to the specification.

Galahs flying with a motion blur. Low frame rates such as 24 and 25 fps cause visible motion blur. However, this anomaly is strongly associated with the visual impression of feature films and is desired by many photographers and cinephiles. Photo: Fir0002/Flagstaffotos (Wikimedia Commons)

This is quite unlike how most other formats have developed into a standard. Normally, new technologies and formats are being introduced to the market by manufacturers with a certain commercial goal. This goes for the 35mm film format, the various wide-screen formats such as CinemaScope and Widescreen 1.85, as well as optical, magnetic and digital sound. Only after a certain level of market penetration will the formats be standardised by bodies such as the SMPTE.

This time around, DCI started with the specification and then expected the manufacturers to deliver hardware and software complying with their requirements. Since standards and specifications can be interpreted differently from company to company, the early days of D-cinema were to a certain extent plagued by playability problems linked to file and equipment variations. Today, compatibility issues have, for the most part, been ironed out.

The open source nature of the DCP is just one of many reasons to be enthusiastic about the concept. DCI sought to devise a system which was equal to – or better than – 35mm film projection. Below are some key characteristics described.

4. 1 FRAME RATE

The frame rate of 24fps was one of the key parameters, which ensured compatibility between 35mm and digital on the projection side, while providing the DOPs (directors of photography) with a comforting resemblance to analogue film. An optional 48fps was also introduced to enable sequential 3-D systems, where the left and right images are projected in sequence.

More recently, alternative frame rates have been included: 25, 50 and 60fps are included to facilitate adaptability with European and US TV content; 16, 18, 20 and 22fps have been included to provide film archives with a selection of frame rates for silent films. These alternative frame rates are optional, meaning that equipment doesn't need to support anything but 24 and 48fps to be considered DCI-compliant.

HFRs (High Frame Rates) are also being devised to eliminate the artefacts associated with a frame rate as low as 24fps, for instance, motion blur, stroboscopic effects, etc. While motion blur is almost a signature of a feature film experience and hence widely accepted as a visual anomaly, it significantly damages the stereoscopic effect crucial to 3-D films. By increasing the frame rate per eye from 24 to 48 or 60fps, the artefacts are significantly reduced. However, HFR sceptics will argue that the image becomes very much "video like" and lacks the familiar touch of a feature film. Regardless of this, DCI and SMPTE are looking at how HFR can be implemented into the current D-cinema platform.

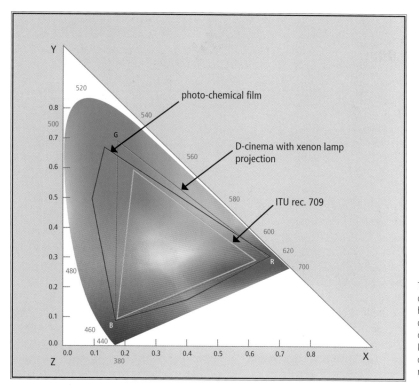

The three-dimensional chromaticity diagram defined by CIE to represent the human visual colour range. Note the difference between the inner triangle (the colour range of HD monitors according to ITU recommendation 709) and the two outer triangles, representing the colour range of D-Cinema and film.

The first HFR feature film is Peter Jackson's *The Hobbit: An Unexpected Journey* (December 2012), which has been shot at 48fps. James Cameron has announced that his future *Avatar* sequels will be running in 3-D at 2 x 60fps.

4.2 COLOUR SPACE

The limited colour resolution and colour range offered by video and TV systems were two reasons that electronic imaging was hated by the DOPs. Well aware of this, DCI was eager to define a colour space, which could match that of film. Not only that – DCI preferred to devise a system that could theoretically include all colours that human beings are able to see.

DCI turned to the XYZ colour space diagram defined back in 1931 by the International Commission on Illumination (CIE – Commission Internationale de l'Eclairage) instead of a specific colour space. This is a three-axis diagram representing colour and lightness, within which a smaller and slightly curved area represents the colours that the human eye can see. (Refer to the APM, chapter 9.1.4 for further details about colour space.)

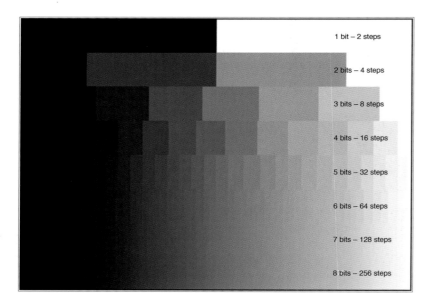

| 1 bit – 2 steps |
| 2 bits – 4 steps |
| 3 bits – 8 steps |
| 4 bits – 16 steps |
| 5 bits – 32 steps |
| 6 bits – 64 steps |
| 7 bits – 128 steps |
| 8 bits – 256 steps |

The bit depth is an expression of how many steps each colour component is divided in, from light to dark. The more bits, the more precise gradients. (After Mikko Kuutti, The Pixel, 2007.)

DCI chose to use the full XYZ triangle when defining colours in the DCP file format. As a consequence, it would theoretically be possible to include colours outside the human visual colour range, though ensuring forward compatibility with future projection platforms was the main reason for "wasting" so much colour information.

The actual colour space of D-cinema is currently limited by the colour range which a digital projector based on a xenon light source can produce. DCI has defined the extreme red, green and blue reference points (P3), as well as the white point, of digital projectors. Those extremes create a triangle of considerably larger area (hence a larger colour space) than that of high definition video (ITU rec. 709). In fact, some areas of the D-cinema colour space include colours outside that of film (particularly in the green area).

Human vision does include colours outside the current triangle, however, and projectors based on lasers rather than xenon light bulbs as a light source have the potential to approximate the human colour range better.

Regardless of where the projector development will lead with respect to colour reproduction, the DCI specification is future proof due to the use of the full XYZ space.

4.3 COLOUR RESOLUTION

While colour space defines how wide the colour range of a system is, colour re-

The effect on bit depth on an image – from 1 bit to 10 bit black & white. (National Audiovisual Archive, Helsinki.)

solution defines how many shades of grey – or rather how many shades of any of the colour primaries – a system can reproduce. Domestic video formats such as DVD and BluRay use eight bits per colour, meaning that the scale from dark to light is divided in 2^8 steps, i.e. 256 steps. This is considerably poorer than film, and DCI again turned to the limits of human vision to define its format.

The bit depth specified by DCI is twelve, meaning that each colour is resolved in 4096 (2^{12}) steps or tones. Taking into account the fact that human vision is non-linear, more of the bits are used to describe changes in the dark sections of the image. In other words, we are using the most bits where the human vision is most sensitive, simply by applying a gamma function. This way, 12-bit resolution is used in the most efficient manner, giving an image quality close to what one would achieve with fourteen bits of linear coding. DCI has specified a gamma of 1/2.6, and the resulting gamma-corrected colour space is referred to as "Cap XYZ prime", often put as X'Y'Z'.

Since the colour resolution matches that of the human eye, there are few reasons to improve the DCI specification in this respect in the future. However, during image capture and post-production, a much higher colour resolution (for instance sixteen bits) can be useful in order to process the images without digital artefacts. Once a DCP has been made, however, twelve bits of non-linear coding remain more than sufficient.

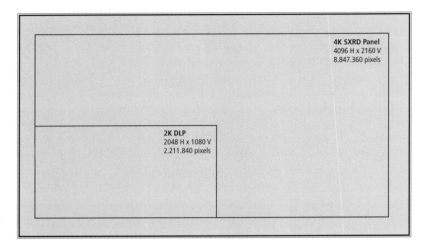

4K SXRD Panel
4096 H x 2160 V
8.847.360 pixels

2K DLP
2048 H x 1080 V
2.211.840 pixels

DCI settled for two D-cinema format containers, 2k and 4k.

4.4 IMAGE RESOLUTION

When the DCI specification was conceived, the technological challenges linked to 4k scans, post-production and projection lead the DCI to agree on 2k as the minimum resolution for D-cinema. The choice was made even though the visual benefits of 4k were well known (refer to Chapter 2 of this booklet).

What has been recognised as the world's first D-cinema presentation, *Star Was Episode 1*, was presented with Texas Instruments' 1.3k DMD chip, but 1.3k has never been DCI-compliant.

That being said, a large percentage of early 2k installations offered little more than 1.3k projection, due to the lack of automatic zoom lenses or "wide adapters" for cinemas with screens of a fixed image height (the same projected image height for 2.39:1 and 1.85:1).

There was also a discussion between the various studios as to whether 4k should be included in the DCI specification at all. Some eager studios felt that including 4k could delay the deployment of D-cinema, whereas other studios were keen to make the specification as future proof as possible by including 4k.

The debate included a number of the arguments also raised in Chapter 2 of this booklet. For instance: to what extent can the audience actually see the difference between 2k and 4k? Also, comparisons to film were made where some would argue that the average 35mm film projection could not even match the resolution of 2k. Others contended that 35mm at its best would be superior to 2k. (A 35mm show-print struck directly from the camera negative and projected on a very steady projector with the latest generation aspherical lenses would certainly in many respects outperform 2k projection, though such screenings were extremely

rare in the mid 2000s. More commonly, a film print would be high-speed printed from a 2k digital intermediate negative and projected on a projection system maintained to medium or low standards. Hence, the average 35mm film screening had huge potential for improvement.)

Neither the 2k camp nor the 4k camp would step down, so DCI settled for a clever compromise: a specification that includes both 2k and 4k.

However, it was important for DCI to ensure that the 2k and 4k formats became entirely compatible: a 4k system should be able to play back a 2k film without image artefacts, and vice versa. DCI achieved this goal by selecting a 4k container, which is exactly four times as large as the 2k container. Also, DCI chose a compression scheme that doesn't require two completely different distribution files for 2k and 4k. The wavelet-based compression scheme JPEG2000 allows the 4k data to be an "add-on" to the 2k baseline data: More specifically, the 4k add-on data contains only the difference in image information between the 4k and 2k images.

A 4k projector will upscale any 2k films during projection, while any 2k playback system will disregard the add-on 4k data when a 4k film is being played back.

4.5 IMAGE CONTAINERS AND ASPECT RATIOS FOR D-CINEMA

The full pixel arrays of 2k and 4k consist of 2,048 x 1,080 pixels and 4,096 x 2,160 pixels, and the pixels are square in shape. These full DCI pixel arrays are only seen as image containers and do not match any commonly used aspect ratios. Instead, the 2.39:1 CinemaScope and 1.85:1 formats are positioned within the containers at optimum resolution.

In 2k, the 1.85:1 flat format will use all 1,080 pixels in height, but only 1998 pixels in width (for 4k the numbers are 2,160 x 3,996 pixels). For 2.39:1 CinemaScope, the full container width is being utilised (2,048 or 4,096 pixels), but only 80% of the container height will be active (858 or 1,716 pixels). The resulting pixel count varies from 1.76Mpx for 2k CinemaScope at one end of the scale to 8.63Mpx for 4k flat at the other.

	2.39:1	1.85:1
2k	2048 x 858 (1.76Mpx)	1998 x1080 (2.16Mpx)
4k	4096 x1714 (7.02Mpx)	3996 x 2160 (8.63Mpx)

The ratios specified by DCI have the disadvantage of offering the smallest number of pixels to the format normally occupying the largest screen area, at least in well-designed theatres with a fixed image height. Needless to say, for this reason, the lowest image quality will be associated with the CinemaScope ratio.

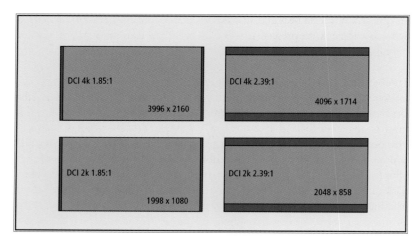

DCI has only specified two aspect ratios per container, i.e. 1.85:1 and 2.39:1 in 2k and 4k.

A pragmatic response to such a complaint has been that many modern cinemas in the US have screens with a fixed image width rather than a fixed image height. For such screens, the chosen approach offers the simplest solution with regard to lenses and projector settings, and the pixel size and illumination will remain the same on the screen regardless of aspect ratio.

As emphasised in the APM however, the entire purpose of the CinemaScope format is to increase the participation effect on patrons. Therefore, cinemas ought to be designed with CinemaScope offering the largest viewing angle and the largest screen area. Following this line of thought indicates that DCI's specification with regard to aspect ratios is not ideal. It certainly increases the relevance of the high-resolution 4k format, particularly for theatres with a fixed screen height and variable screen width.

In the early days of D-cinema, 2k installations in cinemas with a fixed screen height resulted in particularly low resolution for the flat format: The installer would typically zoom the lens out so that the 2,048 pixels would cover the screen width and 858 pixels the image height in CinemaScope. With the lack of an motorised device to zoom the image in to convert from an active height of 858 to a height of 1,080 pixels, the installer would set the projector up so that the flat image height was electronically downscaled onto the 858 pixels image height set for CinemaScope. The effective resolution became only 1,587 x 858 pixels, i.e. 1.36Mpx.

Not only is resolution diminished as a result of applying this trick. In addition, the effective projector brightness suffers, as the lamp and optical system have been designed to light up the full pixel array rather than a fraction of it. Actually, with this approach as much as 37% of the light will be lost in the flat format.

The practice has been heavily criticised by the film studios, and, instead, motorised zoom lenses with presets (lens memory) or anamorphic/wide adapters are recommended.

Another note on resolution and D-cinema: many DCPs have been originated and post-produced on high definition (HD) rather than D-cinema platforms. The consequence is that such DCPs do not always take advantage of the flat and CinemaScope formats specified by DCI. As the HD container is limited to 1920 pixels in width (while maintaining a container height of 1,080 pixels), HD films tend to have slightly lower resolution: 1,920 x 1,038 for 1.85:1 flat and 1,920 x 803 for CinemaScope. To ensure that the screen is filled regardless of the lower resolution, D-cinema projectors should be set up with lens presets for HD in addition to D-cinema.

In addition to films in flat and CinemaScope formats, the 16:9 ratio (1.78:1) used for both broadcast and domestic purposes appears in cinemas from time to time, even though the ratio is not included in the DCI specification. HD programme material in 16:9, either 720 x 1,280 or 1,080 x 1,920, are typically encountered in the form of "alternative content" or independent film productions.

Additionally, the 4:3 ratio (1.33:1) is being used for restored films in the Academy aspect ratio (1.37:1) as well as for films originating from standard definition video (1.33:1). The height will be 1,080 pixels, while the width will vary between 1,436 and 1,480 pixels (at 2k).

4.6 IMAGE COMPRESSION

As mentioned before, JPEG2000 was selected as the compression system partly because it enables a single inventory 2k/4k solution for distribution. JPEG2000 is based on wavelets rather than the discrete cosine transform functions (DCTs), which is the building block for compression systems such as MPEG-2.

Wavelets are mathematical functions which abbreviate a certain word (a row of values) into a shorter word by averaging adjacent values in the word, as well as storing the differences between the original values and the averaged values. In other words, the use of wavelets is an efficient way of storing complex data, such as a high-resolution image.

JPEG2000 is an asymmetrical coding system: the encoder is more complex than the decoder. The compression system is lossless and reversible when the compression ratio is low (up to about 2.8:1). JPEG2000 compression as applied to D-cinema compresses the files in the region of 8:1 to 30:1. Even at such fairly high compression ratios, JPEG2000 has proven extremely transparent, in fact yielding an image where the compression seems virtually lossless. There are also

JPEG2000 wavelet compression. Original uncompressed image. (Andreas Tille)

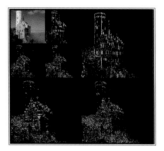

Wavelet decomposition of the image. The original image has been modified in two levels: For each level, the average detail has been reduced, and the horizontal, vertical and diagonal details are shown as negative images surrounding the compressed image. (Alessio Damato after Andreas Tille).

The difference pixel-by-pixel between the above image and its JPEG2000-compressed version: White indicates no-difference; black indicates a big difference. (Alessio Damato after Andreas Tille).

HOW WAVELETS WORK

Contrary to popular belief, wavelets themselves do not compress an image: Their job is to make compression possible. To understand why, suppose that an image is encoded as a series of spatially arranged numbers, such as 1, 3, 7, 9, 8, 8, 6, 2. If each number represents the darkness of a pixel, with 0 being white and 15 being black, then this string represents some kind of gray object (the 7s, 8s, and 9s) against a light background (the 1s, 2s, and 3s).

The simplest kind of multi-resolution analysis filters the image by averaging each pair of adjacent pixels. In the above example, this results in the string 2, 8, 8, 4: a lower-resolution image that still shows a grayish object against a light background. If we wanted to reconstruct a degraded version of the original image from this, we could do so by repeating each number in the string: 2, 2, 8, 8, 8, 8, 4, 4.

Suppose, however, that we wanted to get back the original image perfectly. To do this, we would have to save some additional information in the first step, namely a set of numbers that can be added to or subtracted from the low-resolution signal to obtain the high-resolution signal. In the example, those numbers are -1, -1, 0, and 2. (For example: Adding -1 to the first pixel of the degraded image, 2, gives 1, the first pixel of the original image; subtracting -1 from it gives 3, the second pixel of the original image.)

Thus the first level of the multi-resolution analysis splits the original signal up into a low-resolution part (2, 8, 8, 4) and a high-frequency or "detail" part (-1, -1, 0, 2). (...)

It might not seem that the first step of the wavelet transform has gained anything. There were eight numbers in the original signal, and there are still eight numbers in the transform. But in a typical digital image, most pixels will be very much like their neighbors: Sky pixels will occur next to sky pixels, forest pixels next to forest pixels. This means that the averages of nearby pixels will be almost the same as the original pixels, and so most of the detail coefficients will either be zero or very close to zero. If we simply round those

coefficients off to zero, then the only information we need to keep is the low-resolution image plus a smattering of detail coefficients that did not get rounded off to zero. Thus, the amount of data required to store the image has been compressed by a factor of almost 2. The process of rounding high-precision numbers into lower precision numbers with fewer digits is called quantization (the "Q" in "WSQ"). An example is the process of rounding a number to two significant figures.

The process of transforming and quantizing can be repeated as many times as desired, each time decreasing the bits of information by a factor of almost 2 and slightly degrading the quality of the image. Depending on the needs of the user, the process can be stopped before the lower resolution starts to become apparent, or it can be continued to obtain a very low-resolution "thumbnail" image with layers of increasingly accurate details. With the JPEG-2000 standard, one can achieve compression ratios of 200:1 without a perceptible difference in the quality of the image. Such wavelet decompositions are obtained by averaging more than two nearby pixels at a time. The simplest Daubechies wavelet transform, for instance, combines groups of four pixels, and smoother ones combine six, eight, or more.

One fascinating property of wavelets is that they automatically pick out the same features our eyes do.

The wavelet coefficients that are still left after quantization correspond to pixels that are very different from their neighbors—at the edge of the objects in an image. Thus, wavelets recreate an image mostly by drawing edges—which is exactly what humans do when they sketch a picture. Indeed, some researchers have suggested that the analogy between wavelet transforms and human vision is no accident, and that our neurons filter visual signals in a similar way to wavelets.

"Wavelets: Seeing the Forest and the Trees" was written by science writer Dana Mackenzie, with the assistance of Drs. Ingrid Daubechies, Daniel Kleppner, Stéphane Mallat, Yves Meyer, Mary Beth Ruskai, and Guido Weiss for Beyond Discovery™: The Path from Research to Human Benefit, a project of the National Academy of Sciences, 2001.

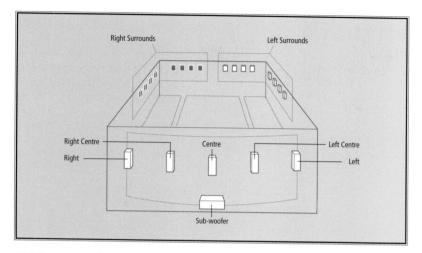

The DCI specification is based on 5.1 channel audio, with an option for two extra screen channels (7.1 SDDS channel layout).

JPEG2000 encoding schemes available, which yield constant image quality from frame to frame by applying a variable bit rate (VBR) approach.

Another advantage with JPEG2000 is that it stores each frame individually. This makes random access fast and easy, and special censorship edits can easily be done on the encoded data for particular territories.

The average bit rate of a D-cinema presentation is approximately 125Mb/sec, while the maximum bit rate is specified as 250Mb/sec at 24fps. The maximum bit rate of D-cinema is in other words 44 times higher than the bit rate of standard definition DVDs and over six times higher than for Blu-Ray HD material.

An average feature film requires a storage space of approximately 150GB (2k) or 300GB (4k). Even though a 4k image contains four times the number of pixels compared to a 2k image, the storage space requirement is only double. This is due to the fact that JPEG2000 compression becomes increasingly efficient as resolution increases, i.e., a 4k image can be compressed at a higher rate than a 2k image without visible artefacts.

4.7 AUDIO

The audio format specified by the DCI is vastly superior to any digital or analogue sound format on 35mm film. Since the image file is so big anyway, the audio represents such a small fraction of the entire file that compression is omitted. In fact, it is a requirement that the audio stays uncompressed through the entire D-cinema playback chain.

DCI has specified sixteen simultaneous channels of uncompressed audio (PCM), sampled at 48 or 96kHz with 24 bits per sample. All sixteen channels

AES Pair#/Ch#	Channel #	Label / Name	Description
1/1	1	L / Left	Far left screen loudspeaker
1/2	2	R / Right	Far right screen loudspeaker
2/1	3	C / Center	Center screen loudspeaker
2/2	4	LFE / Screen	Screen Low Frequency Effects subwoofer loudspeaker
3/1	5	Ls / Left Surround	Left wall surround loudspeaker
3/2	6	Rs / Right Surround	Right wall surround loudspeaker
4/1	7	Lc / Left Center	Mid left to center screen loudspeaker
4/2	8	Rc / Right Center	Mid right to center screen loudspeaker
5/1	9		Unused
5/2	10		Unused / User Defined
6/1	11		Unused / User Defined
6/2	12		Unused / User Defined
7/1	13		Unused / User Defined
7/2	14		Unused / User Defined
8/1	15		Unused / User Defined
8/2	16		Unused / User Defined

The DCI channel routing specified the Left Centre and Right Centre channels to be delivered on track number 7 and 8. Source: DCI System Specification v. 1.2.

are discrete and full-frequency (even though some may carry nothing but low frequency effects).

The high sample rate of 96kHz (optional) allows frequencies above the audible range of 20Hz to 20kHz to be reproduced. Today's cinema sound systems will not reproduce these frequencies.

The high bit rate of 24 bits per sample means that the dynamic range is improved compared to past 16- or 18-bit systems, in fact from 93-105dB to 141dB. However, this benefit won't be noticeable in regular cinema sound systems because the playback standard has not been changed for public health reasons. A reference pink noise signal at –20dBFS (twenty decibels below full scale) on a single stage channel is supposed to be calibrated to a loudness of 85dBC (decibels C-weighted sound pressure level), as was the practice with digital sound on 35mm film. The peak level per stage channel will then be at 105dBC, and, since the noise floor of a cinema at the best of times is in the 25–35dBA range (decibels A-weighted background noise level), the effective dynamic range is typically limited to 75-85dB. Consequently, sixteen or eighteen bits are sufficient for today's standard for playback levels. This "waste" of bits has been taken advantage of by the Auro-3D sound system, which uses the "excessive bits" to code a three-dimensional multi-channel audio experience.

The DCI channel configuration is meant to be flexible, with the standard 5.1 configuration representing the minimum. There is provision for a maximum of 16 channels. The content of each audio channel will obviously be down to the film-maker, who may well choose to release a film with mono sound from the centre channel only.

Channel in package	Configuration			Notes
	5.1	7.1 SDDS	7.1 DS	
1	L	L	L	Left
2	R	R	R	Right
3	C	C	C	Center
4	LFE	LFE	LFE	Screen low frequency effects
5	Ls	Ls	Lss	Left surround (or left side surround)
6	Rs	Rs	Rss	Right surround (or right side surround)
7	HI			Hearing impaired (with emphasis on dialog)
8	VI-N			Visually impaired narrative (audio description)
9	–	Lc	–	Left center
10	–	Rc	–	Right center
11	–	–	Lrs	Left rear surround
12	–	–	Rrs	Right rear surround
13	Motion Data			Synchronous signal (currently used by D-Box)
14		–		Unused at this time
15		–		Unused at this time
16		–		Unused at this time

The ISDCF channel assignment specifies that track number 7 and 8 are used for hearing impaired and visually impaired audio tracks. Furthermore the ISDCF suggests that the Left Centre and Right Centre channels should be delivered on track number 9 and 10 on so-called Interop DCPs, i.e. DCPs provided prior to the implementation of SMPTE DCPs. Source: ISDCF

Note 0. While the table above is a recommendation meant to capture and encourage common practice, it is not guaranteed that all Interop DCPs past, present or future will follow this recommendation.

Note 1. Not all channels need to be present in a given DCP. For instance, only the first 8 channels should be used when delivering 5.1 + HI/VI content. In all cases, an even number of channels shall be used.

Note 2. While some labels are reused across all configurations for convenience, the corresponding channel may not carry the identical signal. For instance, the signal labeled "Lss" in a 7.1 DS mix may not be identical to the signal labeled "Ls" in the 5.1 mix for the same title.

Films with a sound mix taking advantage of optional channels should be compatible with 5.1 channel systems.

Below is a list of playback channels according to DCI v.1.2.

- five main stage channels (L, LC, C, RC, R), of which L, C and R are mandatory
- two main surround channels (LS, RS)
- one low frequency effects channel (LFE)

Films dubbed in other languages can be distributed with separate audio packages of sixteen channels, and the CPL (Composition Play List) will decide which set of audio tracks is to be used.

In practice, D-cinema systems have often been configured with different audio channel assignments to those being suggested by the DCI. For instance, channel 7 and channel 8, which were assigned to the Left Centre and Right Centre

channel in the DCI specification version 1.2, have typically been used for a hearing-impaired monaural track and a sight-impaired commentary track. However, as the requirement for audio channels increases with the introduction of 7.1 and 9.1 audio, these two aiding tracks are going to be reallocated to channels 15 and 16. At the same time, track 11 and track 12 will be allocated to Left Surround Back and Right Surround Back. (*Dolby Surround 7.1 White Paper*, Dolby, 2011).

4.8 WRAPPING AND DISTRIBUTION FILES

The DCP concept is inherently flexible: a DCP can contain as little as one single asset (for instance a sound or picture track file), a packing list and an asset map. However, when we speak about DCPs in everyday language, we normally refer to a complete composition, which can replace a 35mm film print – with audio, image and often also sub-titles. When referring to DCPs in this text, we assume that we are dealing with such a composition.

DCI has carried the concept of "reels" over from analogue film to D-cinema. In other words, a DCP (composition) will typically consist of five to eight reels of approximately twenty minutes in duration. Each reel has its own universally unique identifier (UUID), a tag assigned by the content provider according to UUID guidelines. However, it is fully possible to treat the entire film as a single reel if the content owner wishes to do so. To the projectionist, the two concepts are practically transparent.

The sound and picture are wrapped using MXF (Material eXchange Format) as the standardised format, while sub-titles, playlists and additional files are prepared as XML (Extensible Markup Language) files. XML has the advantage of being both human- and machine-readable. If we are dealing with an SMPTE DCP rather than an Interop-DCP, also the sub-titles will be MXF wrapped.

In addition to the picture, sound and sub-title files, the DCP will also include a composition play list (CPL), which tells the server how, and in which order, to play the files. (Note: the CPL should not be confused with the SPL – a show play list – which the projectionist puts together to compile a show of, e.g., advertisements, trailers and a feature film.)

If the exhibitor wishes to present a film both sub-titled and without sub-titles at different times, two different CPLs are required, even though the image and sound content may be the same.

Finally, the DCP contains a packing list file, a volume index file and an asset map. The packing list file is used by the server during ingest of a film to ensure that all files required for the ingest are intact and have not been corrupted or tampered with. The volume index file is of relevance if the DCP is spread over various

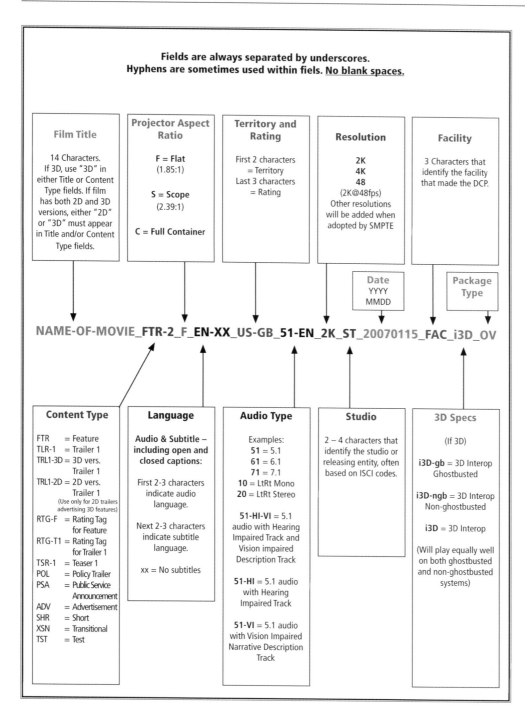

Fields are always separated by underscores.
Hyphens are sometimes used within fiels. No blank spaces.

Film Title

14 Characters.
If 3D, use "3D" in
either Title or Content
Type fields. If film
has both 2D and 3D
versions, either "2D"
or "3D" must appear
in Title and/or Content
Type fields.

Projector Aspect Ratio

F = Flat
(1.85:1)

S = Scope
(2.39:1)

C = Full Container

Territory and Rating

First 2 characters
= Territory
Last 3 characters
= Rating

Resolution

2K
4K
48
(2K@48fps)
Other resolutions
will be added when
adopted by SMPTE

Facility

3 Characters that
identify the facility
that made the DCP.

Date
YYYY
MMDD

Package Type

NAME-OF-MOVIE_FTR-2_F_EN-XX_US-GB_51-EN_2K_ST_20070115_FAC_i3D_OV

Content Type

FTR = Feature
TLR-1 = Trailer 1
TRL1-3D = 3D vers. Trailer 1
TRL1-2D = 2D vers. Trailer 1
(Use only for 2D trailers advertising 3D features)
RTG-F = Rating Tag for Feature
RTG-T1 = Rating Tag for Trailer 1
TSR-1 = Teaser 1
POL = Policy Trailer
PSA = Public Service Announcement
ADV = Advertisement
SHR = Short
XSN = Transitional
TST = Test

Language

Audio & Subtitle –
including open and
closed captions:

First 2-3 characters
indicate audio
language.

Next 2-3 characters
indicate subtitle
language.

xx = No subtitles

Audio Type

Examples:
51 = 5.1
61 = 6.1
71 = 7.1
10 = LtRt Mono
20 = LtRt Stereo

51-HI-VI = 5.1
audio with Hearing
Impaired Track and
Vision impaired
Description Track

51-HI = 5.1 audio
with Hearing
Impaired Track

51-VI = 5.1 audio
with Vision Impaired
Narrative Description
Track

Studio

2 – 4 characters that
identify the studio or
releasing entity, often
based on ISCI codes.

3D Specs

(If 3D)

i3D-gb = 3D Interop
Ghostbusted

i3D-ngb = 3D Interop
Non-ghostbusted

i3D = 3D Interop

(Will play equally well
on both ghostbusted
and non-ghostbusted
systems)

The digital cinema naming convention
assists the projectionist in finding out
how a DCP should be played back.
(digitalcinemanamingconvention.com).

volumes (for instance, multiple DVDs) before being ingested into the server, while the asset map is a list of all the files which make up the DCP.

4.9 NAMING OF DCPS

The name of a DCP will show up in the user interface of the playback server, but since graphic displays and Theatre Management System (TMS) software may have only a limited number of characters available to present the name of the DCP, it is important that as much useful information as possible is compressed into the first part of the title. Furthermore, a universal labeling structure is a very useful tool for the projectionist in deciding how to play a DCP back correctly. Therefore, the Inter-Society Digital Cinema Forum (ISDCF) and the film studios have agreed on a naming convention, known as the Digital Cinema Naming Convention. The naming convention standardises how to abbreviate and label everything from image and sound format to subtitling, 3-D system and distribution territory.

digitalcinemanamingconvention.com

It is actually through this very naming convention that metadata is transported in the D-cinema sphere. To improve the metadata transport mechanism in the future, the ISDCF has also prepared a working draft on Composition Metadata Guildelines.

isdcf.com/papers/ISDCF-Doc6-Composition-Metadata-Guidelines.pdf

4.10 SECURITY AND KEYS

DCI has striven to make content theft as difficult as possible by specifying a complex system of encryption, forensic marking and secure keys. Crucial to the system is that the audio and video can be encrypted using 128-bit security. Most content providers have chosen to encrypt their films, while some independent film distributors have chosen to provide entirely unencrypted material – the DCI specification supports both approaches.

Even though a key is required to play back encrypted content, it is fully possible to ingest the DCP before the key is available or valid. This ensures that the time-consuming ingest process can be done well in advance of the first screening of the film.

To unlock encrypted content, a key known as a KDM (Key Delivery Message) is required. The KDM is both unique to the content and to the auditorium – or rather to the equipment installed in the relevant auditorium.

Each playback server has a cert file (certificate file), which the cinema needs to provide the content distributor with in order to have a KDM generated. The file uses the PEM format (Privacy Enhanced Mail, file extension .pem). In some cases, these cert files are distributed automatically to the content providers through management systems, or they may be made available to the film distributors by the integrator, which was responsible for the initial installation. In other cases, the projectionist will have to retrieve the cert file from the playback server manually and send it to the film distributor, most commonly as an e-mail attachment. Once the cert file has been received by the KDM provider (often this will be the DCP mastering facility), the content provider will be able to generate a KDM.

The KDM is a small xml-file (file extension .xml). Sometimes, multiple KDMs are bundled together and delivered as a compressed zip-file (.zip). Delivery to the cinema may be insecure (for instance by e-mail), since the key has no value unless one has the hardware to play back the film for which the key was created.

Once the key has been delivered to the cinema, the projectionist can ingest it manually, for instance through a USB memory stick, which is inserted in a USB port in the server. In other set-ups, a central management system in the cinema (TMS) will automatically make sure that all available keys at a site are delivered to the relevant auditorium. Other systems allow KDM ingest via a PC and the SMS controller.

Key distribution from the distributor to the site and/or the auditorium has been one of the major hassles with D-cinema so far, and the introduction of a fully automated method is long overdue. The new key distribution concept, TKR (Theatre Key Retrieval), which has been proposed by Mike Radford (Fox) and John Hurst (Cinecert), addresses this concern, and it is strongly supported by the ISDCF. The approach includes a simple URL (internet address) in the delivered composition (CPL), where the playback server can go to find the key.

According to ISDCF's Jerry Pierce, the design is such that the distributor has full control of which keys are released, they can update them locally, and the theatres can retrieve the keys as needed as well as replace those that are expiring. If the TKR system is widely adopted, the current cumbersome key distribution system consisting of a mix of delivery platforms can finally be discontinued.

Some private enterprises have also launched systems for automatic key delivery, such as Unique Digital's Basekey system.

The KDM will normally be valid from the premiere date, and it will expire at a set date and time. If the film is supposed to run past this date/time, an entirely new KDM has to be generated.

The KDM policy may often stop cinemas from doing test-runs of films prior to the agreed time of the premiere. Due to time zone differences, it is not uncommon for a KDM to be generated to start or to expire at the correct time, but based on an incorrect time zone. Checking the KDM is possible, both with the playback server and by opening the file in a computer and studying the text of the key.

The KDM is only valid for a certain version of the film (a particular content play list, CPL). This means that two keys are normally needed if a cinema is showing both the original and the dubbed version of the same film.

Another security requirement is that the server and projector must be "married" to each other. In other words, an encrypted film can't be played back unless the server and projector have been linked and communicate over the network at all times. Initially, this functionality was not in place; now, however, this concept of married hardware in an auditorium is mandatory.

If the server is changed for some reason, a new cert file will have to be retrieved, and new KDMs be delivered for all relevant content.

4.11 HARDWARE SECURITY

Encrypted content is of little help if the digital video signal is tapped between the server/media block and the projector. Consequently, DCI requires that the video signal is protected through the playback chain. Servers and projectors are required to comply with Federal Information Processing Standard (FIPS) publication 140-2, which, for instance, means that critical electronics are protected from physical interference. The projector and media block shells are required to be tamper-proof; if they are opened, the system will automatically stop the playback. The tampering will be logged in the event log, and the film can only be restarted once qualified and trusted personnel have reset the system.

The security concept also requires the media block to be a part of the projector itself, or that the digital video data is transferred to the projector through an encrypted link.

While the latter approach was most commonly used initially, taking advantage of an SMPTE 292M dual link HD-SDI connection, it is now increasingly common to use an integrated media block. The bandwidth of the dual-link HD-SDI in its current form allows for only 10-bit colour and 2k resolution. (The DCI specification has included this single exception to the general 12-bit requirement.)

From day one, DCI-compliant Sony 4k systems have been utilising an integrated media block since the bandwidth of dual-link HD-SDI was too limited to cater for 4k. Another possible reason for this design choice is that the link encryption

used, CineLink, was developed by one of Sony's main competitors.

The manufacturers of DLP-based D-cinema systems are now moving towards integrated media blocks, too, as they are pursuing high-bandwidth technologies such as HFR (high frame rates) and 4k.

4.12 WATERMARKING

Many films are stolen during projection through the use of digital video camcorders in auditoria. DCI has consequently also called for forensic watermarking, which makes it possible to trace the exact screening, cinema and location where the content theft took place. Forensic watermarking in current use includes Thomson's NexGuard and Philips's CineFence. In fact, Civolution – a spin-off company from Philips Corporate Technologies – has acquired Thomson's watermarking business and is now handling both systems. D-cinema servers will at least support one of the watermarking systems.

Watermarking can be done to the image, audio or both. (In the alternative content sphere, audio watermarking has become popular, for instance, the Cinavia system introduced by Verance.)

CHAPTER 5 **PROJECTION SYSTEMS**

5.0 BASIC PROJECTOR TECHNOLOGY

Projectors for digital images are designed to modulate light so that a digital image file is converted to a full-colour analogue image, projected on a screen for an audience. The heart of a digital projector is therefore the light-modulating device, i.e. the "engine" that will control the light bundle from the projector light source, ensuring that the right amount of light for each colour hits the screen at any given time during the show.

In order to categorise digital projectors, it is common practice to specify the type of light modulator and the number of modulators used inside the projector.

DCI-compliant projectors are currently equipped with DMD or SXRD light modulators (see below), whereas projectors for general use may instead be equipped with LCD (Liquid-Crystal Display) or D-ILA (Direct Drive Image Light Amplifier) panels.

In an ideal world for digital projectors in general, and as a strict DCI requirement for D-cinema projectors, there will be one light modulator for each primary colour: red, green and blue. Projectors equipped accordingly are commonly referred to as three-chip projectors, and they tend to be more expensive than one-chip projectors using the same type of light modulator.

5.1 LCD PROJECTORS

Liquid crystals are materials with partly solid phase, partly liquid phase prop-

Recombining prism with LCD matrix.
(MaDCocktail)

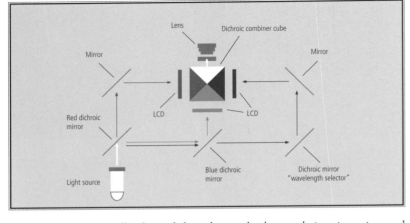

LCD projection

erties. When electrically charged, liquid crystals change their orientation and their transparency if combined with pre-polarised light. The liquid crystals are sandwiched between two pieces of glass with polarising properties. Thin film transistors (TFTs) are used to charge the crystals for each pixel, causing the light to be either blocked or let through. The extent of the charge will control to what degree the light is blocked, meaning that the light valve function is analogue. (Different voltages result in different levels of light transmission.)

In other words, the LCD projector is a transmissive system, where the light passes through the image-creating device in the following manner: white light from the light source (typically a metal-halide lamp) is split into the three primary colours, red, green and blue, by colour-discriminating dichroic mirrors. Each colour is then switched by individual LCD panels, before the light is re-combined in a prism and projected onto the screen with a projection lens.

The advantages of the system are that it is inexpensive, light weight and very light efficient. A wide range of resolutions is available, fitting various requirements and budgets.

On the downside, the distance between each pixel is fairly big compared to what's achievable with DLP and LCoS (Liquid Crystal on Silicon), since the liquid crystals are surrounded with a grid of switching transistors. The grid is particularly noticeable at a relatively short viewing distance, and this phenomenon is referred to as the "screen door effect". Furthermore, the contrast ratio is lower than what is achievable with DLP and LCoS – typically the sequential contrast ratio is in the range of 800:1 to 1.500:1, unless a contrast-enhancing system is included (for instance, active iris technology). The intra-frame contrast of LCD projectors is rarely published, but practical experience indicates that it is not at all as high as similar DLP or LCoS projectors.

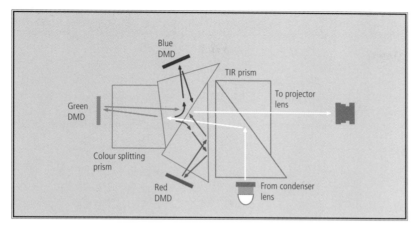

The DMD chip is the core of the DLP technology: (Texas Instruments)

3-chip DLP projection.

The speed of the LCD system is limited, meaning that lag may be noticeable during fast motion sequences.

A final disadvantage with LCD projectors is that the longevity of the panels is affected by heat. The colour reproduction will change over time, depending on levels of heat exposure.

5.2 DLP PROJECTORS

The heart of DLP technology is a tiny chip or DMD (Digital Micromirror Device), patented by Texas Instruments. This chip is covered with a number of moving mirrors that corresponds to the number of pixels being projected. Each mirror is fixed to the chip with a tiny "rod" placed in the middle of the square mirror. Each pixel on the chip has an address to which a switching command can be sent to activate a mirror movement. When a beam of light is directed to this chip, the light will either be directed into the projection lens/combination prism (on-state of the chip) or onto a light absorber (off-state of the chip). The DLP chip is thus a binary device with only two states, so grey scales are created by switching the chip on and off in rapid succession during the projection of one single image. The rapidly switched pixel will appear as a pixel with a certain light level, and the relationship between how long the pixel is in the on-state and how long it is in the off-state will govern which gray-level is being projected (pulse-width modulation).

DLP projectors exist in 1-chip, 2-chip and 3-chip versions. The 3-chip version provides by far the best picture quality and is the one preferred for high-end applications – and the only approved DLP system for D-cinema. The white light is split into the three primary colours, red, green and blue, and there is one DMD in place per colour. The modulated light is collected into a combination prism before being projected onto the screen.

In a 1-chip projector, the colours are split in the time domain, rather than the frequency domain, by means of a spinning colour wheel with three (sometimes more) colour sections in red, green and blue, and the single chip therefore modulates one colour at a time. Because of the fast speed of the wheel, the three colours are integrated and perceived as a full colour image by the human eye/ brain. However, some people may be bothered by the rainbow effect that can be seen on high-contrast elements in the picture when the viewer shifts his or her focus from one point on the screen to another. This effect is particularly noticeable in the peripheral parts of the vision where speed sensitivity is the highest.

The DLP projector has revolutionised the projector industry as the system offers vast light output (using standard cinema light sources like xenon lamps for the bigger models), high contrast ratios (2000:1 and better) and high resolution (initially limited to 2k for D-cinema purposes, now also up to 4k). The high-end version of DLP was the first technology to be endorsed by Hollywood studios for D-cinema presentations. Today, an estimated 70-75% of D-cinemas worldwide are equipped with DLP projector systems.

DLP projectors have proven quite reliable, though the light engine can fail. A single faulty pixel will normally require a change of the entire light engine, so extended warranty plans are highly recommended. However, DLP projectors require less frequent colour calibration than projectors with LCoS techology. In fact, due to the binary nature of the DMD, the colour consistency is remarkable.

While DLP D-cinema projectors are historically known for their high contrast levels, contrast ratios are not expected to go much beyond 2,200:1 any time soon except for laser projectors. In comparison, there are already SXRD projectors launched with a claimed average contrast ratio of 8,000:1.

5.3 LCOS AND SXRD

One variety of the LCD technology is known as LCoS, Liquid Crystal on Silicon of which D-ILA and SXRD (Silicon Xtal Reflective Display) are the most commonly known varieties. D-ILA was introduced by Hughes and JVC and is currently used on JVC's high-end home cinema projectors, while Sony introduced SXRD to D-cinema as well as TVs and home cinema projectors.

Unlike LCD systems, LCoS is based on light reflection rather than light transmission. The main principle for D-ILA and SXRD can be described as follows: A silicon chip with a reflective aluminium layer is coated with liquid crystals. The silicon chip also contains the switching circuitry for each pixel (CMOS/ FET). White light from the projector light source is polarised and divided into three, one bundle for each primary colour, in a polarising beam splitter (PBS). Each bundle is sent to its individual chip for modulation. Varying degrees of light

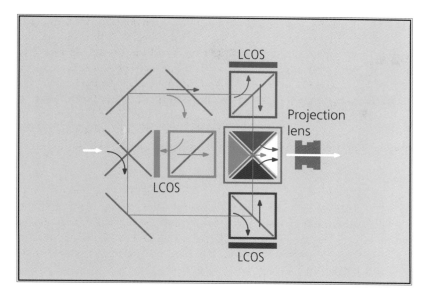

4k SXRD chip (Sony).

Principle of LCoS projection, such as SXRD.

deflection will take place in the liquid crystal layer depending on the applied voltage, which in turn is controlled by the transistors. The light reflected from each chip will finally be recombined into one full-colour picture and projected through the projection lens.

The main advantage of this technology is that the pixel density can be much higher than is the case for LCD. It was the first – and for a long time the only – technology to offer 4k D-cinema projection, and it is the first to offer 4k in home theatres (Sony VPL-VW1000ES). Because of the high pixel density and the very tiny dark area between each pixel, the pixels are much more difficult to spot than is the case with competing systems, creating a smoother and more film-like image. The system is also less prone to thermal problems than LCD systems.

The downside of the early LCoS projectors was the fairly limited contrast ratio and low light output (compared to DLP). However, Sony refined LCoS technology by vertically aligning the pixels in the SXRD panels and managed to be the first non-DLP projector manufacturer to achieve DCI compliance.

Today, SXRD projectors are available with light outputs up to 21,000 ANSI Lumens (SRX-R220/320) thanks to the use of a 4.2kW xenon lamp. While this is sufficiently high to cover most cinema screens in 2-D, competing DLP projectors can offer 33,000 ANSI Lumens and more, since the DLP light engine can handle the more intense heat associated with higher-wattage xenon lamps.

Above: UHP lamps are commonly used in E-cinema and home cinema projectors, but they have now also been introduced to D-cinema (Sony)

Right: The xenon lamp has been the primary light source for both analogue and digital cinema. However, lasers and ultra-high pressure lamps have now entered the D-cinema scene. (Philips)

Recently, a new type of SXRD projector has been launched for D-cinema, which is claimed to offer an average contrast ratio of 8,000:1 (sequential contrast), double that of similar DLP projectors. At the time of writing, the intra-frame contrast ratio is not known, however. Furthermore, these projectors are currently limited to 15,000 ANSI Lumen in light output.

The main disadvantage with SXRD projectors installed to date is that they require more frequent colour calibration than DLP projectors. Colour shading across the image can be an issue after a period of operation, particularly when high-wattage bulbs are being used. While this phenomenon is often not noticeable when colour films are being projected, it is fairly easy to spot when black and white films are being screened. Therefore, archive cinemas should ideally schedule colour calibration every six months should they choose to install SXRD projectors.

It is not yet known if the latest generation SXRD projectors, utilising a cluster of UHP lamps, will require less frequent calibration, but it is likely to be the case due to less heat hitting the chips.

5.4 PROJECTOR LIGHT SOURCE

An important projector parameter is the type of light source used. From an image quality standpoint, it is vital that the light source emits a sufficient amount of light across the entire visible colour spectrum, enabling projection with the fullest possible colour range. The xenon lamp is the most commonly used light source with such properties – the light emitted is not only of a very wide range, but the spectrum is also continuous and fairly linear compared to most other light sources. Because of these advantages, currently, all but one DCI-compliant digital projector utilise xenon bulbs. Some very few high-end home cinema projectors have also been equipped with xenon lamps to offer the widest possible colour range (Sony VPL-VW100/200).

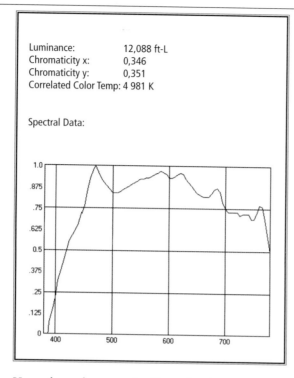

Luminance: 12,088 ft-L
Chromaticity x: 0,346
Chromaticity y: 0,351
Correlated Color Temp: 4 981 K

Spectral Data:

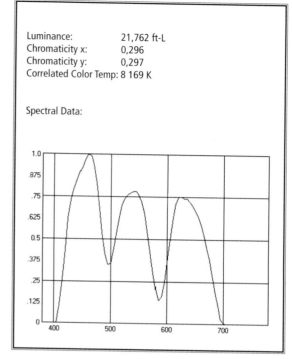

Luminance: 21,762 ft-L
Chromaticity x: 0,296
Chromaticity y: 0,297
Correlated Color Temp: 8 169 K

Spectral Data:

Xenon lamps have one significant disadvantage, however: The energy efficiency is not ideal, meaning that the number of lumens produced compared to the energy consumed is rather low. In fact, xenon projector lamps produce as little as 30-50 lumens per Watt (l/W), which translates to around five per cent efficiency. Waste of energy is one consequence, and with regard to projector design, heat management becomes a crucial factor.

Most projectors outside the D-cinema world therefore utilise other light sources, commonly metal-halide lamps or other forms of ultra-high pressure discharge lamps (UHP lamps). Metal-halide lamps are typically filled with gases such as argon, mercury or xenon under very high pressure in combination with halides such as sodium iodide and scandium iodide. The luminous efficiency is high compared to xenon – in the 20% range. The colour spectrum will depend on the exact combination of gases, but it is not quite as wide in range as xenon light, and there are certain gaps in the spectrum (non-continuous spectrum), which could be an issue depending on where the gaps are located in relation to the projection system's colour primaries. In particular, the deep-red part of the spectrum tends to be limited, for example, with skin tones appearing slightly orange.

Until Sony launched their latest 4k D-cinema projector in 2012 (SRX-R515), such discharge lamps were not used in DCI-compliant projectors due to the

Left: The light output from an analogue film projector with a xenon light source. The spectrum is continuous and fairly linear.

Right: The raw white light output from a D-cinema projector with a xenon light source (Christie CP-2000). The continuous spectrum from the xenon lamp has been divided in three colour components, R – G – B.

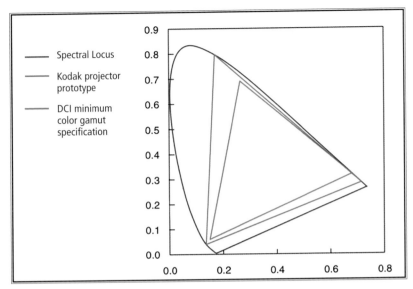

Laser projection as applied by Kodak
in their prototype D-cinema projector
offers a large colour range than xenon
projection. (Kodak)

challenges associated with limited colour range. However, by applying an array of six lamps, Sony claims to achieve sufficient light across the required colour spectrum while at the same time reducing power consumption. Equally important – the longevity of the SXRD light engine is expected to improve as a consequence of less heat hitting the panels.

5.5 DCI AND PROJECTOR PERFORMANCE REQUIREMENTS

To ensure quality consistency, DCI has laid down a number of projector requirements linked to resolution, colour range and contrast. The requirements are rather strict, except perhaps when it comes to contrast, where a certain level of pragmatism paved the way for the earliest possible paradigm change from film to digital.

When comparing D-cinema to film, one of the weakest points of digital projectors is the limited contrast ratio. Contrast is typically specified as sequential contrast, meaning the difference in projected luminance between one entirely black frame and a sequential entirely white frame. A more demanding way of specifying contrast is to state the intra-frame contrast ratio (ANSI contrast ratio), which is the measured chequerboard contrast within one frame. Projectors yielding acceptable contrast by today's standards may have a sequential contrast ratio of 1,500:1, while the ANSI contrast ratio may only be 150:1.

DCI requires that projectors used for D-cinema purposes yield a nominal sequential contrast ratio of a minimum 2,000:1, while the intra-frame ratio should be a minimum of 150:1. When projector contrast is measured on site, a tolerance down to 1200:1 or 100:1 is allowed in regular cinemas (1,500:1 for review rooms).

On-site measurements can be done with a luminance meter, where the luminance of the peak-white is divided by the luminance of the absolute black. As a comparison, the theoretical contrast ratio of Kodak's Vision print film is 8,000:1. Despite the fact that the contrast is reduced during projection through lenses, portholes and stray light, ratios above 2,000:1 were common in high-quality cinemas showing 35mm film.

With regard to image brightness, the illumination in the centre of the screen is supposed to be $48cd/m^2$ (= fourteen foot-Lamberts). The allowed tolerance in cinemas is +/− $10.2cd/m^2$ (+/− $2.4cd/m^2$ for review rooms). $48cd/m^2$ is actually approximately 14% lower than the current industry standard for film projectors, but the offset is introduced to ensure consistency between film and digital, taking into account the fact that the film base is not fully transparent.

The specification for the evenness of illumination allows a maximum drop-off to the corners and sides of 25% in regular cinemas, and this is similar to film projector requirements.

DCI requires that the projector be free from visible lag, colour shading and other image artefacts.

The displayed colour space must at least include a specific set of X, Y and Z values as well as a fixed white point. During playback, the projector must convert the X'Y'Z' colour space values of the image file to the projector's native colour space.

5.6 CHOOSING A PROJECTOR

The projector is the most expensive item in a D-cinema system, and it is by far the item that affects image quality the most. Since not all projectors can be combined with all servers or media blocks, it makes sense to choose the projector first, then the other components in the system.

Based on the assumption that your cinema has decided to go for the D-cinema platform, one might perhaps ask: which D-cinema projector will be right for the average archive cinema?

Just as it is impossible to write a book about which car to buy for the "average Joe", it is not possible to present a universal answer to this question. A number of individual parameters will decide what the best option is for a specific theatre, and, at the end of the day, everything from the budget to a certain level of personal taste and preference could tip the balance. When choosing a car, it is not uncommon to choose the after-sales service over the car manufacturer. The same logic could also be applied to projector choice.

The first production generation of D-cinema projectors were pretty bulky: Barco DP-100, Christie CP-2000, NEC NC-2500 and Sony SRX-R220.

Moving to Series-2 DLP and the second-generation DCI-compliant Sony projector: Barco DP2k15C, Christie CP-2230, NEC NC2000C and Sony SRX-R320.

From a technical standpoint, the first parameters to look at are screen size, image framing and 3-D capability, as they all govern the requirement for projector light output. Start your calculation by looking at the maximum image width in your theatre. Normally, CinemaScope offers the widest image in archival theatres, and if the image width is e.g. ten metres, you will have to calculate on the basis of a screen area of ten metres multiplied by the theoretical image height. In our case, the theoretical image height is ten metres divided by a factor of 1.89. Why not 2.39, which is the factor for CinemaScope, you might ask?

The answer is that the image chip in the projector has an aspect ratio of 1.89:1. Hence, the lens must be zoomed out to cover the full screen width while "wasting" light and resolution over and under the active part of the image. For the purposes of your calculation, the screen area will be 10 x 5.29 metres, i.e. 52.9 square metres. An alternative is to equip the projector with an anamorphic lens; however such lenses are both costly and bulky, meaning that their practical use is limited to the very largest screens which otherwise can't be sufficiently lit.

When calculating the required light output, you should also take into account light calibration losses in the projector, light losses in the projection porthole and losses due to projector lamp wear. For a ten-metre-wide matte white screen, a projector output of around 9,000 ANSI-Lumens in 2-D will typically be required. This number will increase to 14,000–20,000 ANSI-Lumens in 3-D, depending on the type of 3-D system, the screen type and the desired 3-D luminance level (for instance 3.5, 5 or 6 foot-Lamberts).

A good integrator will be capable of both doing and explaining the exact luminance calculations for a specific theatre. Indeed, the light calculation is a good way of testing the capabilities of the integrator. Resist the temptation to trust most the integrator, who offers the smallest projectors. Rather, trust the integrator who has taken all possible losses into account, bearing in mind the reference status of archive cinemas – not to mention their use as preview rooms for restored archive films.

Once you know what kind of light output you require, it is time to look at the resolution. The topic is thoroughly explained in Chapter 3, and unless your cinema has a very small screen compared to the viewing distance – or unless your financial situation makes the 4k choice impossible – go for a 4k projector! At the very least, choose a projector, which can be upgraded to 4k later, ensuring that the integrator/dealer will commit to an upgrade price and time-scale.

With regard to 3-D, there are a number of considerations to be made, as discussed in Chapter 6. If you have very firm preferences with regard to 3-D systems, you have to be aware that these will limit your selection of projectors.

5.7 DLP OR SXRD?

Assuming that the choice of 3-D technology is not the main purchase criterion, it is now time to choose between DLP technology developed by Texas Instruments and implemented in projectors from Barco/Kinoton, NEC or Christie, and SXRD technology developed and implemented by Sony. In order to make the right choice, the myths and facts about the technologies must be looked at.

First a bit of background. Sony came late to the D-cinema market and needed a competitive edge against the three other manufacturers, all of which use the DLP system. Sony decided to commit to the 4k resolution platform, a premium feature they alone were to offer until late 2010. By September 2011, Sony had passed the 10,000 unit mark for their 4k system (Sony press release, October 2011), thereby securing a market share of approximately 25%.

The Sony 4k system is fully compatible with 2k or 4k systems from competing manufacturers. The system can play back the same standardised SMPTE DCPs as all other servers/projectors, since all hardware and software have been designed with DCI compliancy in mind. A 4k system of any brand should play back any 2k film as easily as a 2k system.

The latest addition to the D-cinema projector range includes Barco's cost-effective DP2k-10Sx and Sony's SRX-R515. The Barco projector is thought to be in the 30,000 euro range, including server, storage and media block. The resolution is limited to 2k. The Sony product provides 4k resolution, a UHP light source, a contrast range expanded to 8,000:1 and a lens changing mechanism, facilitating a faster lens change between 2-D and 3-D. The cost is thought to be in the 45,000 euro range, including server, storage and media block.

In the early days of D-cinema, however, customers reported more playability problems linked to DCP file inconsistencies with the Sony 4k server than other servers. In particular, DCPs with subtitles could cause problems. Some of the issues were linked to DCPs not being fully DCI/SMPTE-compliant, while others were connected to system software bugs which have since been ironed out. At present, no DCP compatibility issues are known with the latest versions of software and firmware in the field.

Some differences between Sony's projector and the DLP based projectors from Barco, Christie and NEC should be mentioned:

- Sony's projector systems are always 4k, while other systems are most often 2k (though some of these can be upgraded to 4k).
- Sony's projector systems are equipped with projector optics, which are superior to most other projection lenses in the D-cinema sphere as far as MTF is concerned. (Modulation Transfer Function is the true measure of the resolving power of the lens, which takes into account contrast as well as the ability to resolve fine details). The reason is that the projector was designed for 4k resolution from day one.
- Sony 4k systems cannot be equipped with xenon lamps with higher wattage than 4.2 kW. This means that the projector's light output is in the range of approximately 21,000 ANSI-Lumens. The light output is sufficient to provide the SMPTE standard of 14 foot-Lamberts in 2-D on a CinemaScope screen of 20–21 metres in width and with a screen gain of 1.8, without the use of an anamorphic adapter.

Kodak's prototype laser projector (Kodak).

With an anamorphic lens, the maximum screen width can be increased to approximately 24 metres. In contrast, DLP projectors with xenon lamps offer a light output of 33,000 ANSI-Lumens or more.

- Even though the SXRD panel switching speed is high at five milliseconds, the speed is not sufficiently high for 3-D systems utilising an alternating frame approach. Currently, only the 3-D systems from Real-D can be combined with the Sony 4k system. Real-D utilises a dual-lens approach when applied to Sony's 4k projectors, requiring a lens change between 3-D screenings and 4k 2-D screenings. The benefit with a dual lens approach is that the 3-D colour resolution is the same as for 2-D images. The disadvantage is that the lens change is somewhat cumbersome.
- The higher pixel density associated with SXRD panels compared to 2k DMD panels yields a smoother-looking image in the author's experience, even if the content played is only 2k.
- Despite their reflective nature, the SXRD panels are more sensitive to heat than DMD panels. In the long term, this may affect the longevity of the SXRD panels, particularly for projectors equipped with high-wattage xenon bulbs. However, Sony does offer a warranty package, partly offsetting this risk. Also, sudden failures of SXRD light engines are extremely rare, while sudden failures of DLP light engines have not been uncommon.
- The SXRD panels are more prone to colour shading over time than DMD panels. Therefore, colour calibration must take place more frequently with these than with DMD based projectors. Colour shading is particularly an issue when projecting black-and-white film. It should be noted that the latest addition to the Sony range of projectors, the SRX-R515, which uses a different light source, may be less prone to colour shading and other issues caused by heat hitting the SXRD panels than the xenon-based SXRD projectors.
- The Sony 4k system is normally supplied with Sony's own server and media block. While it is possible to install "alien" servers/media blocks (a server system from Doremi is currently available for this purpose), very few such systems are installed in the field.
- The latest 4k system launched, the SRX-R515, yields a contrast ratio of 8,000:1, significantly higher than that of today's DLP projectors.

As can be seen, it is far from clear cut which projector technology one should settle for. It will depend on priorities and the level of support which the various manufacturers are capable of in the relevant territory. Last, but not least: do your own tests and comparisons, and keep in mind that new technologies, such as laser technologies, are in the pipeline and may shift the market very soon.

5.8 OTHER PROJECTOR CHARACTERISTICS RELEVANT TO FILM ARCHIVES

There are other important requirements to keep in mind when choosing a projector. Here are some of the most important to an archive cinema:

- Physical size: will the projector system fit the projector booth, keeping in mind that most film archives would like to keep their analogue film projectors?
- Component size: when dismantled, can the projector system components be brought from the goods entrance of the building to the projection booth without building conversions?
- Power supply: what kind of electrical power does the projector require? Single phase or three phase? Which voltage options are available, and how complicated will it be to adapt the electrical system in the booth to the projector power requirements?
- Heat extraction: how much heat does the projector generate, and does the projector booth offer sufficient air extraction? Some projectors require external fan extraction, while others have a sufficient number of built-in fans. If the latter, be aware that while the fans may provide the correct air flow, the projector will still heat up the projection booth unless air is extracted or unless cooling systems are installed. Also keep in mind that reliability is dependent on operating temperature.
- Lens focal length: digital projectors are normally equipped with zoom lenses. However, do not take for granted that the projector you would like to buy can be equipped with a zoom lens covering the exact magnification ratios required for your desired image sizes. Well-designed archival cinemas operate with a fixed image height and a variable image width, so the image will have to be zoomed out for CinemaScope 2.39:1 and potentially also 2.21:1 (Todd-AO) and 2.76:1 (Ultra Panavision 70). Image formats less wide than 1.89:1 (such as 1.85:1, 1.66:1, 1.37:1, 1.33:1 and 1.19:1), could normally be operated at one zoom setting, since "pillarboxing" ensures the correct aspect ratio on screen. Make sure that the zoom range of the projector lens at least covers the full image height for both the 2.39:1 and 1.85:1 ratios by specifying the correct lens factor. The factor of the lens is the figure that you should multiply the image width by to reach the projection distance. For instance: if your fixed image height is 4.2 metres, the image width for 2.39:1 is 10 metres, while the 1.85:1 format will be 7.77 metres wide and the 1.89:1 format 7.94 metres wide. For lens calculation purposes, only the 2.39 and 1.89 image width figures matter. With a projection distance of 20 metres, you will need a lens with a factor covering at least the range of 2.00x to 2.52x. Ideally, you should also include the slightly smaller HD CinemaScope ratio of 1920 x 803 pixels (CinemaScope for D-cinema covers 2048 x 857 pixels). The magnification will have to be 7% higher since the image is that much smaller. In the above example, the lens factor must be a maximum 1.87x instead of 2.00x, while the minimum figure will remain at 2.52x.

- Lens motor and memory: as archival cinemas are more likely to screen films with various aspect ratios, good motorised lens preset systems are required. Some projectors require the lens motor to zoom the lens to an extreme position for each lens change, taking an unacceptable amount of time, while other projectors are notorious for imprecise lens presets. Certain projectors are even sold entirely without motorised zoom lenses. These should be avoided for an archival cinema. Ask for demonstrations and references.
- Frame rates: a projector system capable of multiple frame rates is particularly important for archival cinemas. Both the projector and server system should cover as many frame rates as possible. An absolute minimum is 24, 25, 50 and 60fps, but also the archival frame rates of 16, 18, 20, and 22 fps should be included. See Chapter 5.11 for further details. Also make sure that the projector and server are capable of switching between one frame rate and another within one show play list – and without unacceptable delays. Short films and pre-show content should play seamlessly with the main feature, without glitches.
- User interface: while modern multiplex cinemas are normally fully automated, an archival cinema requires careful projection work and showmanship. Therefore, the user interface of the projection system should be carefully investigated before making a purchase decision. Having to step through multiple menu layers to do a common and simple task is not desirable.
- Installer capability and support: D-cinema systems requires careful set-up, alignment and maintenance. It is of little use to have the best cinema equipment in the world if it is incorrectly set up and maintained. Consequently, be sure to select equipment for which you are able to get good support locally.
- Warranty package: Ensure that the equipment provider is able to supply a proper warranty package. See Chapter 5.12 for further details.

5.9 SERVER AND MEDIA BLOCK

Early D-cinema systems normally consisted of a projector, a D-cinema server and in some cases an image scaler/processor. When cinema technicians referred to the "D-cinema server", they typically meant an integrated system, which consisted of a show management system (SMS), a storage server with redundant disks (RAID – Redundant Array of Independent Disks) and a media block.

The media block is the part of the D-cinema playback system which prepares the film content as output from the storage system during playback to a video and audio signal. Some of these D-cinema servers also included sound cards with eight-channel analogue audio output as well as general purpose automation inputs and outputs (GPIOs). A typical example of such a device is the first generation Doremi DCP-2000 system, which could include all these functions – as well as a touch screen with a graphic user interface – in one piece of hardware.

Other manufacturers, such as Dolby, have chosen a modular approach where the

data storage, media block, automation control, sound converter and user interface consist of individual "boxes" tied together over the network.

In both cases, the media block was separated from the projector. By encrypting the video signal going from the media block to the projector (using the proprietary CineLink link encryption system), the video signals could not be copied for the purposes of content theft, even though the media block was located outside the "secure" projector shell.

Since there was no readily available link encryption system for 4k video signals when 4k was first introduced for D-cinema by Sony, 4k systems were, instead, furnished with a built-in media block, SMS and storage server. Here, the physical projector casing, rather than link encryption, provides a certain security level. In these systems, also the playback server was built in to the projector/pedestal casing. With this layout, the 4k video data is transferred from the media block to the projector electronics using unencrypted LVDS (Low Voltage Digital Signalling).

As the 2k projector manufacturers were expanding the DMD/DLP technology to 4k with the Texas Instruments Series-2 projectors, the concept with a built-in media block became more widespread, as these projectors can either have an integrated or a separate media block. If the media block is built in to the projector casing, the video signal is sent to the projector directly over a PCI Express interface.

With the introduction of Barco's latest low-cost projection system, the DP2K-10Sx, a complete media server is built into the projector. The term "media server" covers the media block, the SMS and the storage device. In other words, this system is a self-contained all-inclusive package, just as are Sony's 4k systems.

With an integrated media block, the video signals don't have to be link encrypted, enabling high-bandwidth technologies such as high resolution (4k) and/or high frame rates (for instance 2 x 60fps).

Some manufacturers of built-in media blocks (such as Doremi) have chosen to include various scaler, source selector and imaging processor functions in their media blocks, thereby rendering the external imaging processor/video scaler superfluous. The media blocks may also be equipped with HDMI inputs for external non-D-cinema video sources.

Under certain circumstances, it is possible to upgrade from an external to an integrated media block. Series-2 DLP projectors are designed with this functionality in mind. Series-1 projectors, on the contrary, cannot be upgraded.

The Doremi DCP-2000 server is an "all in one" unit. The earlier version of the system could also be fitted with an eight-channel analogue output board. (Doremi)

The early Dolby approach represents Doremi's opposite extreme. The DSS100 Show Store and the DSP100 Show Player also require a separate keyboard and monitor in addition to the NA10 automation interface and the DMA8 or DMA8-plus audio adapter. (Dolby)

Today, it is getting increasingly common to utilise an integrated media block. The media block could be manufactured by the projector manufacturer, the server manufacturer or a third party. This is Doremi's integrated media block. (Doremi)

Sony LMT-300 media block is integrated into the SRX-R320 projector. (Sony)

5.10 CHOOSING A SERVER/MEDIA BLOCK

Since it is increasingly common to include the media block and sometimes also the storage server in the projector, the choice of projector may trump whatever preference one has with regard to D-cinema server. That aside, below are some ideal server and media block selection criteria:

- Reliability: choose a D-cinema server which is known to be reliable and which is covered by good support.
- Versatility: choose a D-cinema server that accepts as many types of DCPs as possible. Prior to the introduction of fully SMPTE-compliant DCPs, small variations in the packaging could cause certain servers to fail to playback a film. Also, the server should ideally be compatible with any 3-D format while at the same time offering 4k and high frame rate support. Furthermore, it is advantageous if the server will accept the playback of non-JPEG DCPs based on MPEG image compression. Frame rates of 16, 18, 20, 22, 24 and 25 fps should also be supported.
- Ingest interface: ingesting a film is very time consuming. A D-cinema server with high-speed ingest ports is therefore strongly recommended. In addition to standard USB and ethernet ports, the server should be equipped with a high speed port such as an eSATA (External Serial Advanced Technology Attachment) for instance in the form of a CRU-port.
- Storage space: a feature film could require as little as 50GB or as much as 500GB of data. The type of content and its duration, resolution and frame rate will govern the storage requirement. For an archival cinema, it is absolutely critical to have a large storage system. 2TB is an absolute minimum, and it is recommended to add an external storage system in the form of a TMS, offering at least another 10TB of storage space.
- Modern D-cinema servers may also include inputs for external sources. While this is a big plus, archival cinemas tend to require an external image processor/ video scaler anyway, since the number of external sources can be high and since there is often a need for image preview during a show.

5.11 ARCHIVAL FRAME RATE SUPPORT

The SMPTE Archival Frame Rate standard – demanding as it was to get it through SMPTE at all – is a voluntary standard (SMPTE ST 428-21:2011 Archive Frame Rates for D-Cinema). As such, the manufacturers of projectors and servers will only implement the standard if the market demand for this functionality is sufficient.

The frame rates 16, 18, 20 and 22 fps come short when classic silent films are supposed to be presented at a number of frame rates within one show. These are instructions for the German film "Alt Heidelberg" (1924).
Source: Unknown

Consequently, it is important that all film archives and cinémathèques put archival frame rate support as a requirement whenever they prepare a tender for a D-cinema system. While the purchasing power of film archives is limited compared to that of commercial cinemas, one may find that a particular manufacturer (typically one without market dominance in a certain territory) will consider this functionality if it can secure some extra sales. Once one manufacturer supports the standard, it will be more difficult for others to ignore it.

The frame rates covered by the standard are 16, 18, 20 and 22fps. To be precise, 18 and 22fps are actually specified to 200/11 (18.1818fps) and 240/11 (21.818181fps) to allow for an integer number of sound samples per frame – and also for an integer number of clock cycles of the 74.5MHz clock generators present in many media blocks.

The selection of frame rates in this standard is a compromise between the desire to present any frame rate without frame-rate conversion and what is possible

The Mechau motor and its speed adjustment system. A tachometer mounted on the projector indicated the projection speed.

SILENT FILM AND PROJECTION SPEED

Projectors were commonly equipped with variable speed mechanisms, something which is confirmed in this booklet about the Mechau film projector. This interesting excerpt also confirms how the film speed was adjusted according to the cinema's schedule.

Excerpt from the booklet "Der Mechau-Projektor", 13th volume of "Die Bücher des Lichtspielvorführers", by R. Hock, Saale – Germany, ca 1934:

"During the silent film era, the adjustment of the projection speed was of the utmost importance, because various circumstances such as different duration of the films and the need to run the same program on the shortened time slots on Sundays, would neccessitate faster or slower projection. Generally, electric resistors were used to adjust the projection speed. One of the most important requirements with regard to the speed adjustment, namely to operate at the set projection speed, could normally not be met with this technology, as the value of the resistor would change as the temperature increased. Furthermore, electric energy was wasted in the resistor. The requirement to operate at a set projection speed has become even more important after the introduction of sound, because the smallest speed change is noticeable as a change in pitch.

Instead of an electric resistor, a friction gear has been employed, which adjusts the speed through mechanical means. It is a matter of an abrasive plate gear, and the operating principle is illustrated in the drawing. By shifting the motor shaft in relation to the projector drive shaft, the speed can be adjusted infinitely."

The drawing shows how the motor shaft can be shifted in relation to the main drive shaft of the projector.

NICOLA MAZZANTI ON SILENT FILM SPEEDS:

Films were shot and shown at various frame rates, even more so when the cameras were still hand-cranked (which can be as late as the day before sound came). The important concept to realise is that there was no direct relation between the shooting frame rate and the projection frame rate at the time. In other words a film was shot at "x fps" and then shown at "y fps". Furthermore, it is proven that "y" was almost always higher than "x". The projectionists during the silent film era were used to control the projector speed, either through hand-cranking or through the use of variable-speed projectors. Projectionists would hurry up certain scenes (e.g. chases) and slow down others (love 'interests'). That's what the cue sheet from "Alt-Heidelberg" (page 69) shows. Furthermore, projection speeds were different from one venue to another, or they could vary depending on the cinema schedules: matinees were screened faster than evening shows!

Also keep in mind that hand cranked cameras were still in use up to the arrival of sound. There was no 'one frame rate' for the whole movie, different scenes were shot at different frame rates, for many reasons: different cameras, choice, or fitness or habit of the cameraman. Whenever multiple cameras and multiple operators were used (and this was common, particularly in the late teens and twenties – all Chaplins were for example shot with at least three cameras running simultaneously) we see that each camera ran at a different speed with a significant difference, even two or three frames per second. In one case that I studied, we could ascertain that the main cameraman was shooting 2fps slower than the assistant running camera number two. Difference in age could play a role: the young, fit assistant ran at almost 24, the famous and old (or simply tired) first cameraman between 21 and 22!

So, bottomline, any modern projection is a simulation of the original experience, until we invent a hand cranked digital projector! So an averaged-out speed is always used, which makes sense as we have little concrete information about the actual speed used at the time.

Today the real problem regarding archival frame rates is that although the standard exists, no manufacturer seems to be interested in implementing it, although it is not that expensive. So both commercial and repertoire cinemas are forced to buy equipment that cannot run anything but 24fps, 25 fps and HFR.

This translates in restorations with lots of artifacts due to frame rate conversion, which occupy unnecessarily up to 30% more space in the server. Not very useful, I would say.

Archives have been tinkering with projectors since the thirties in order to be able to screen silent films, so the fact that we must tinker with files and 'stretch them' is no news. Just an unnecessary waste of time, money and quality!

I am still confident that one day somebody will notice that the archival frame rate standard exists!

Nicola Mazzanti, president of Association of European Cinémathèques (ACE) and conservator of Cinémathèque Royale de Belgique/Koninklijk Belgisch Filmarchief (Brussels)

from a practical and political standpoint within SMPTE. Critics of the standard may claim that silent films were presented in a number of other speeds and that being locked to such a limited number is a significant disadvantage. However, the speed-precision of pre-sound feature films has always been limited due to the use of primitive variable speed projector motors (DC governor motors etc.), and due to hand-cranking.

Also, a number of films had a variable speed regime with approximate frame-rate figures. Therefore, the speeds available are probably going to cover the majority of film archives' needs once they are implemented in hardware.

It is worth mentioning that speeds of 16fps and 20fps can be used practically in cinemas without implementation of archival frame rates by tripling the frames and using the 48fps and 60fps rates that most D-cinema systems today can handle. However, this produces DCPs three times bigger than needed.

From a hardware and software standpoint, implementing archive frame rates in a server is a fairly minor item. On the projector side, however, it could be more of a technical challenge. This is especially the case for DLP projectors, since the DMD system uses variable mirror movement as a way to modulate the light. The DMD is a binary device, which is either on or off, and to create shades of gray, it is necessary to toggle the mirror between these to extreme states in fast sequence. Changing the frame rate, means recalculating the mirror movements while ensuring that no image artefacts occur. Even though the recalculation process is primarily a matter of "leg work", it has a cost involved, which the manufacturers have to feel confident will be recouped through increased projector sales.

SXRD projectors, on the other hand, use light valves with a fixed modulator position for each light level (per frame). The implementation of other-than-standard frame rates was already done when the projectors were first launched, and archival frame rates should theoretically be fairly easy to implement, pending good will on the manufacturer's side.

The transport stream poses a second challenge: D-cinema systems utilising an external media block are tied to the serial digital interface (SMPTE HD-SDI/DC-SDI) for video data transport, which does not include frame rates such as 18 and 22fps.

Even if one is using an external computer with a DCP player application such as Easy-DCP to play archival frame rates, one will be tied to some kind of transport stream with a limited selection of frame rates, whether it is a matter of a DVI or an HD-SDI interface. In other words, even though the DCP player application plays back at 18fps, the video output from the computer will have to conform to some kind of DVI- or SDI- compatible refresh rate, for instance 17, 23.98, 24, 25, 29.97, 30, 35, 50, 59.94, 60, 75 or 85Hz.

5.12 EQUIPMENT LIFETIME AND WARRANTY

D-cinema equipment should be amortised within ten years. This is not to say that good D-cinema equipment can't last substantially longer. However, this is the maximum manufacturer guarantee one can reasonably hope to acquire. While D-cinema equipment normally has a one-year warranty included in the basic price, good vendors are able to supply an additional warranty package covering up to ten years in total. After a period of ten years, the problem of obsolescence

for electronic circuits is likely to make the projector and server difficult (though not necessarily impossible) to maintain.

For cinemas and archives used to analogue film projectors and their lifetime of more than fifty years, this represents a huge shift in culture. Some may claim that renewal of their cinema equipment every ten years is going to be financially impossible. However, more frequent replacements of electronic equipment are inevitable.

The best way of ensuring that the D-cinema manufacturers favour a product design where longevity is key is to keep purchasing those eight- or ten-year warranty plans.

5.13 PREPARING THE PROJECTION BOOTH

Prior to the installation of a D-cinema system, you have to prepare the projection booth. The following aspects should be taken into account:

- Power supply: make sure that your electrical distribution panel has the capacity to support the chosen D-cinema projector. Avoid the D-cinema system being routed via the main power switch of the projection booth, as D-cinemas systems ought to be "live" and connected to the network at all times for monitoring purposes, etc. Some D-cinema systems are supplied with UPS systems (uninterrupted power supplies), while others require a UPS to be installed externally. A UPS is needed to avoid equipment failures in the case of power outages – the UPS will keep the equipment alive for some minutes while the equipment is shutting down in a controlled manner.
- Grounding: sensitive digital projection equipment requires a proper electric grounding structure. Refer to p.290 in the APM for details.
- Static electric charge: avoid a projection room environment, which creates a build-up of static electricity charges. Keep the humidity around 50%RH (relative humidity), and ensure that the floor has an anti-static coating while being electrically conducting and connected to the electrical ground plane.
- Network: implement a high-quality gigabit network with redundancy by the use of high-end managed and monitored network switches. Whether using fibre or copper (category 7e twisted pair), ensure that the network is installed by qualified engineers, who have experience with high-bandwidth networks. A slow network equates to a long ingest time from the central TMS server. An unreliable network equates to an unreliable D-cinema system.
- Wireless router: install a dedicated wireless router for projector service purposes. With such a router, a cinema engineer can access the projector during set-up in a simple fashion, significantly reducing the time it takes to calibrate the equipment.
- Port hole: replace the glass with a type which is anti-reflex coated and with

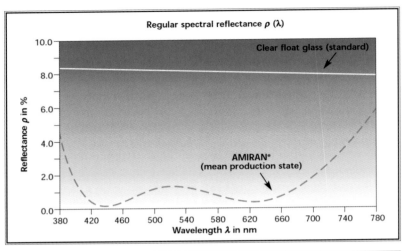

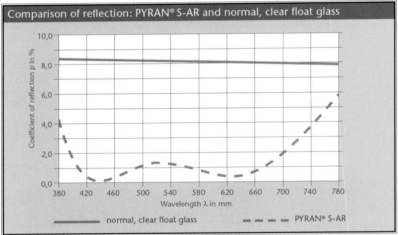

Schott Pyran S-AR and Schott Amiran reflection properties. (Schott)

pure water-white characteristics. Choose the low-iron version of Schott Amiran / Schott Mirogard or glass types with identical properties from other manufacturers. If fire-hardening is required, the best option is to use automatic fire shutters in front of the port holes, as fire-hardened glass tend to be less transparent and/or has de-polarising properties. As a last resort, one can use Schott Pyran-S-AR, which is both anti-reflex coated and fire-hardened – though not quite as ideal as Amiran or Miroguard.

• Ventilation: ensure that the ventilation system offers sufficient air extraction. 500 to 1,500 cubic metres of extracted air per hour are common numbers for digital projectors. Systems where analogue film projectors and the D-cinema

projector cannot be operated at the same time due to ventilation restrictions should be avoided. Also make sure that the ventilation can be controlled from the projection booth and doesn't require special access.

- Projector positioning: keep in mind that, even though digital projectors offer lens shift, it is often necessary to tilt or pan the projector to hit the screen. Trapezoid projection distortion is the inevitable result, but the anomaly can be masked with digital masking systems. Screen geometry advice covered in the APM (Chapter 2.3.3, p.24) still applies unless your projector offers sufficient lens shift. In any case, lens shift may affect image quality (evenness of illumination, sharpness). For these reasons, a D-cinema projector should be positioned as close as possible to a perpendicular line at the centre of the screen. Also, make sure that the projector position allows space for the 3-D system you plan on using.

- Sound: ensure that your playback system is of a sufficiently high quality and that you have the capability to receive an eight-channel AES/EBU digital audio signal. See Chapter 7 for further details.

CHAPTER 6 **3-D SYSTEMS**

6.0 INTRODUCTION TO STEREOSCOPY

The human ability to perceive depth visually is greatly dependent on the fact that our two eyes see two slightly different images due to their lateral off-set. (This off-set averages 6.5cm in an adult human being.)

The difference in angular perspective caused by this lateral eye off-set is the key for the brain to perceive a three-dimensional image. Obviously, the vision of both eyes must be intact. This ability is known as stereoscopic vision or three-dimensional vision.

Other factors also contribute greatly to our sensation of depth, such as the activation of our peripheral vision and indeed our perception of perspective, relative size of objects, as well as light and shadow. However, the fact that our eyes actually see two off-set images is by far the most powerful element in the visual perception of a three-dimensional space.

Techniques for recording and reproducing stereoscopic images, whether moving or still, are therefore all based on the same basic principle: two separate images are recorded and reproduced for the left and the right eye respectively.

Stereoscopic images are normally recorded with two separate cameras mounted together, or with one camera which has a dual optical system built in (stereoscopic camera). The lens off-set should theoretically be the same as the eye off-set for the average human (6.5cm) to give the most realistic result. However,

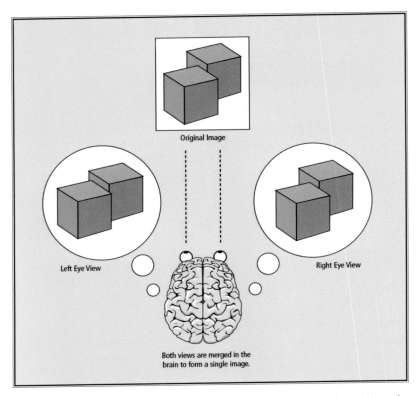

The difference in angular persepctive caused by the lateral eye off-set is the key for the brain to perceive a three-dimensional image. (How stuff works)

by increasing the lens off-set to a higher value, a larger (artificial) depth can be created to achieve an effect.

As far as contemporary stereoscopic film is concerned, two separate left and right images can be recorded with stereoscopic cameras and played back with a D-cinema server and projector. Computer-animated films represent an easier path to 3-D films, as the computer can be programmed to output two slightly different points of view of the three-dimensional objects that are already generated in the animation process. Consequently, a large majority of early D-cinema films in 3-D were indeed animated.

Thanks to digital post-production technology, it is also possible to convert a standard two-dimensional film into 3-D after its release through a process known as "dimensionalisation". The company In-Three pioneered a digital process and workflow, which enabled conversion of 2-D content to 3-D. Other companies have developed similar processes, for example, Stereo D, who did the conversion of James Cameron's *Titanic* (1997) to 3-D in 2012, based on a 4k scan of the original 35mm film. Dimensionalisation is cumbersome and time consuming, and the result cannot be compared to stereoscopically shot 3-D.

Regardless of how the content is generated, the main technical challenge related to 3-D film presentation is linked to finding an answer to the following question: how can we arrange things so that a large group of people, such as in a cinema, can see two separate images in such a way that only the left eye sees the left image and the right eye the right image?

Three core technologies are used for 3-D film presentations in digital cinemas: electronic shutters, polarisation of light and colour discrimination through wavelength multiplex (dual colour triplets). Common to all these three technologies is that they require the use of glasses and that the light requirement is substantial. Systems based on polarisation require special silver screens, while the other two systems can be used in combination with any kind of screen.

Auto-stereoscopic technologies, i.e., systems not requiring the use of glasses, are unlikely to reach cinemas any time soon, as they represent a number of inherent challenges when applied to large audiences. Such systems require slitted or lenticular screens, and the correct 3-D effect is only experienced at certain head positions. For smaller screens and groups, eye-tracking systems adjusting the display to the eye positions are possible, but for larger audiences and screens, such technologies are much harder to implement, if at all possible. The Russian 3-D cinemas in the 1940s did experiment with auto-stereoscopic systems for films such as *Robinson Crusoe* (1947), but they soon reverted to 3-D systems with glasses.

6.1 POLARISATION AND 3-D

From physics, we know that light is a form of electromagnetic waves, and that those waves normally vibrate in all directions in a random manner. One can polarise the light by passing it through a filter so that the waves only vibrate in one single plane (linear polarisation). If two such filters are rotated 90° in relation to each other, light will be almost entirely blocked. With linear polarisation it is possible to feed the left eye with an image polarised in one direction, and the right eye with another image polarised in another direction. As long as the audience wears polarisation glasses with opposite polarisation properties, each eye will only see one image. The principle has been the preferred method of 3-D film projection since the late 1930s (APM, p 172), but one disadvantage is that the audience needs to wear the glasses absolutely level. If the glasses are just a couple of degrees off, the audience will see a double image (known as "ghosting" for ghost images).

There is, however, an alternative solution: linearly polarised light has vertical and horizontal wave components, which are in phase. Filter materials exist, which can slow down the vertical component in relation to the horisontal component so that they are out of phase. When slowed down to a quarter of the wavelength,

Circular polarization

Above: When light is polarised in the linear manner and passed through a circular polarisation filter, the vertical component of the electromagnetic wave is delayed compared to the horisontal component. (After RKM3d.)

Right: 3-D projection utilising linear polarisation and two projectors. The same principle can as easily be applied to digital projection, just as it was for analogue projection in the early 1950-ies. However, to avoid buying two projectors, most D-cinema 3-D setups are using a single projector and the alternate-frame or split-frame approach. Circular polarisation is preferred over linear polarisation, even though the image separation is poorer.

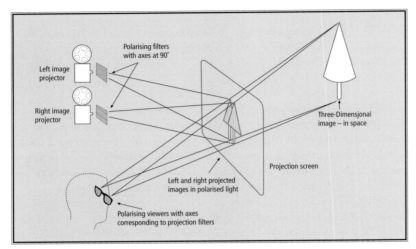

the light will appear to travel in a circular fashion, hence the expression circular polarisation.

Through the use of circular polarisation filters rather than linear ones, the audience's glasses do not have to be copmletely level as long as the correct filter is in front of the correct eye. More importantly, various polarisation devices (such as spinning filter wheels) can be employed in front of a single projection lens, thereby polarising the images in two different directions in sequence.

Circular polarisation has somewhat poorer channel separation than best-case linear polarisation. In practice, this means that there is still a certain tendency to see double images (ghosting), particularly noticeable in high-contrast scenes. The degree to which this is visible depends on the type of circular polarisation used.

One of the primary benefits with polarisation systems is that it is possible to use inexpensive disposable glasses with passive filter technology. This is particularly important for cinemas with large audiences or with a lack of staffing to collect and clean glasses between shows. Furthermore, polarisation systems tend to be the most light efficient.

The main disadvantage with polarisation 3-D systems is the absolute requirement for a silver screen. Such screens have a directional reflection pattern (the screen gain is 2.6 or more), causing the image to look unevenly lit. The effect is always present, but the extent to which it is disturbing depends on factors such as room geometry, relative image size, image position versus audience position, etc.

The 3-D systems Real-D, DepthQ and MasterImage all use polarisation.

6.2 REAL-D

Real-D was the first to grab a large 3-D market share within D-cinema, and it is the most light efficient of the 3-D systems (up to 28% efficiency when using the XL version of the system).

The core technology is an electronically-activated light modulator, which is placed in front of a standard projection lens on a DLP projector. The light modulator polarises the light in a "left pattern" and a "right pattern" in sequence. The projector outputs left and right images in sequence, with a frame rate of 2 x 24fps (48fps). However, the human eye will see movement artefacts at such low refresh rates, so each image will be projected three times in the following sequence: L-R-L-R-L-R. The principle is known as "triple flash" since each image is "flashed" on the screen three times, and even though the file frame rate is only 48fps, the projection frame rate is 144fps. The high bandwidth associated with such a high frame rate was excessive for early-generation DLP projectors. Two solutions were applied in the field: either a "double flash" approach, leading to some visible motion artefacts, or a downscaled image on the chip, leading to lower resolution and even less light output.

Real-D supplies two different kinds of light modulators for DLP projectors: the Z screen and the XL system. The latter system polarises the light twice by "recycling" some of the lost light in the first polarisation process, polarising it again for projection of a second, superimposed image, thereby increasing efficiency. The disadvantage with the system is that it is slightly complicated to align and set up, and it also takes more space.

For SXRD projectors, which are unable to project at such a high frame rate as 144fps, Real-D uses standard fixed circular polarisation filters in front of a dual-lens adapter developed by Sony. The dual lens resembles optical systems used for single-strip 3-D projection on 35mm and 70mm film, and the SXRD chip is divided in a left and right section, just as the case is with single-strip over/under 3-D on film. The advantage of a dual lens approach is that both images are projected simultaneously – eliminating motion artefacts – while there is no dark-time between images. The lack of dark-time equates to improved efficiency. At the same time, the light bundle from the projector is divided in two, and there is also a very slight resolution loss due to the division lines between the left and right image area of the chip.

Regardless of whether Real-D is used in combination with DLP or SXRD projectors, an ingenious technology is applied to counter the problem with ghosting, referred to as "ghostbusting".

Ghostbusting software anticipates the visible light leakage in every single left

The Z-screen is the electro-optical LCD-device, which performs the polarisation for Real-D when positioned in front of the projector lens. (FX Guide / Real-D)

The XL-system is designed for those threates requiring maximum light output. The light is polarised twice, "recycling" some of the wasted light in the first polarisation process. (Kinoton)

Disposable glasses from Real-D utilising circular polarisation. The main benefit of circular and linear polarisation is that glasses are inexpensive to manufacture. (Midori Iro)

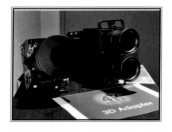

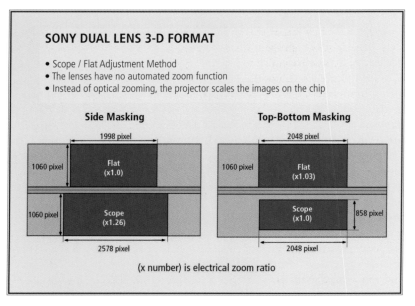

SONY DUAL LENS 3-D FORMAT

- Scope / Flat Adjustment Method
- The lenses have no automated zoom function
- Instead of optical zooming, the projector scales the images on the chip

Side Masking

1998 pixel

1060 pixel — Flat (x1.0)

1060 pixel — Scope (x1.26)

2578 pixel

Top-Bottom Masking

2048 pixel

1060 pixel — Flat (x1.03)

Scope (x1.0) — 858 pixel

2048 pixel

(x number) is electrical zoom ratio

Top: Sony has designed a dual lens system, which replaces the large 4k lens of the Sony projector for 3-D presentations. Currently, only Real-D provides filters for the dual lens, but technically other polarising filters would also do. An exclusive license agreement between Sony and Real-D prohibits the use of other polarising filters in combination with the dual lens projection optics. Real-D markets the system as XLS. (Sony)

Above: The Sony SRX-R220 with the 3-D lens installed. The lens change from 2-D to 3-D is somewhat cumbersome, but Sony's latest projector, the SRX-R515, is furnished with a quick lens mount, making the lens change simple. (Sony)

Right: The Sony 3-D system puts the left and right 2k images on the 4k SXRD chip simultaneously. The image layout will depend on whether the cinema is operating at a fixed screen height or a fixed image height. A bit of cropping does occur, from 1080 to 1060 pixels, but at only 2%, the cropping is rather minor.

and right frame, and manipulates the frame content so that the visible leakage is minimised. In the early days of digital 3-D, special DCPs with ghostbusted images were distributed to cinemas using Real-D. However, since the other 3-D systems don't require ghostbusting and will be disturbed by a ghostbusted file, dual DCP inventory became necessary. The film studios demanded a change to avoid such a logistical nightmare, and, since late 2009, the cinema servers carry out the ghostbusting process on the fly. Even with ghostbusting applied, ghosting is visible from time to time.

Real-D is the only system currently available both for SXRD projectors and DMD projectors. The same glasses and screens are used regardless of projector type, and, in a cinema with multiple screens using different kinds of projectors, this is obviously an attractive feature.

The Real-D system is leased rather than sold, and the fee structure depends on the nature of the cinema. For an archival cinema, the best strategy would be to try to negotiate a preview room deal, where one pays a fixed amount per screen per year. For large commercial cinemas, the calculation with regard to the cost of Real-D compared to its competitors is more complicated since Real-D will normally charge a fee per ticket. Some cinema circuits have reacted against Real-D for cost reasons; however, an archival cinema will be likely to find Real-D's system attractively priced as long as a preview room deal has been secured.

6.3 DEPTHQ

DepthQ is one of the recent additions to the range of 3-D solutions for D-cinema. It was developed by Lightspeed Design Inc in the US and LC-Tec Displays AB in Sweden, and it is rather similar to Real-D in that it has an electronically activated LCD-based light modulator in front of the projection lens, which polarises the light in opposite circular directions in sequence.

The main advantage compared to Real-D is that its light modulator is extremely fast at fifty microseconds, meaning that the system can accept a shorter dark-time between images than other systems. In turn, this optimises light efficiency. Also, DepthQ is compatible with future high frame rate 3-D systems (beyond 240fps) thanks to the fast switching speed.

From a business standpoint, DepthQ is very straightforward without any leasing or complicated contract systems. The system is purchased outright, has a three-year warranty and is fairly low in cost.

The disadvantage with DepthQ is that it can't be used for SXRD-based D-cinema projectors, and it does not exist in an "XL version", meaning that the light efficiency is only better than Real-D's Z-screen, not the XL system. The light efficiency of DepthQ is not published, but the maximum projectable image size was announced by the company to be 17.7 metres. (Maximum allowable projector output for the system is 30,000 ANSI-Lumens.)

From an image quality standpoint, the channel separation is said to be sufficiently good to render ghostbusting superfluous, though a certain level of ghosting is noticeable during high contrast/large image separation sequences.

6.4 MASTERIMAGE

MasterImage is also based on circular polarisation, but, instead of using electronically activated polarisation adapters, MasterImage uses foil style polarisation filters glued to a rotating glass disc. The system is in the medium range, in light efficiency terms. It is not as light efficient as Real-D's XL system, but it is more efficient than RGB colour triplet systems.

The foil style polarisation filters are said to be sufficiently good at cancelling light that ghostbusting isn't required. For this author, this is a surprising claim given that circular polarisation is used. Field experience indicates that ghosting is an issue, but the same can be said about most other 3-D systems.

The glasses used by MasterImage are compatible with Real-D's glasses since both are using passive circular polarisation.

The DepthQ modulator resembles Real-D's Z-screen, but it is announced to be switching faster and with better channel separation. There is, however, a maximum light limit that applies to standard xenon lamp projectors. (DepthQ)

The MasterImage system is based on a rotating disc with a number of polarising filter sectors, ensuring sequential polarisation for the left and right eye. The main advantage with the system is low cost. (MasterImage)

MasterImage cannot be combined with SXRD projectors, and a silver screen is required.

MasterImage's primary business structure is based on sale rather than lease. In many cases, MasterImage will turn out cheaper than Real-D.

6.5 POLARISATION AND SCREENS

Silver screen surfaces are not recommended for standard film projection due to their extreme reflection factor and the resulting light drop-off to the sides. The further the audience is away from the centre line perpendicular to the screen, the more noticeable the light drop-off will be. If the seating area of the auditorium is very wide compared to the distance to the screen, the drop-off may be so severe that the edge seats cannot be utilised as long as the picture is projected on a silver screen.

For this reason, silver screens should be used exclusively for 3-D film presentations based on the polarisation process. As a consequence it is strongly recommended that you install a silver motorised roller screen permanently, which can be lowered in front of the normal screen. Black sound-transparent masking should cover the normal screen during 3-D shows to avoid reflection artefacts. If a sound processor with multiple room-EQ profiles is available, one can programme a special EQ preset for 3-D films, where the slight audio effect of a double screen (treble loss) is compensated for .

The silver screen must be of high quality to maintain the polarisation effect and to avoid picture artefacts. Below is a list of issues to look into when choosing a screen:

- Is the silver screen surface of the highest quality and developed with 3-D projection in mind?
- Are the seams truly invisible?
- Is the screen appropriately perforated for sound transparency?

It is recommended that you obtain a screen from a well-regarded manufacturer, such as Harkness Screens, MDI Screens, Mocom Screens, Stewart Screens, DaLite Screens etc.

6.6 ACTIVE SHUTTER SYSTEMS AND XPAND

Since digital 3-D with DLP projectors is normally achieved by projecting the left and right images in fast sequence, a practical way of blocking the light is to use glasses with active shutters. Active shutter technology is well known from the computer and home cinema domains, but in the professional cinema sphere, the company XpanD, previously known as NuVision, is the dominant supplier of active shutter systems.

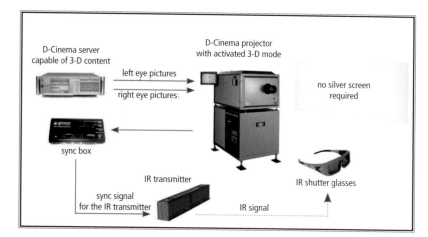

Above: XpanD active glasses.

Left: The XpanD system consists of a sync box, an IR transmitter and active battery-operated glasses. (Kinoton)

An infra-red transmitter is located in the porthole or in the cinema so that the active glasses will receive synchronisation signals, ensuring that the shutters are activated at the correct time. The transmitter is in turn connected to the GPO (general purpose output) of the D-cinema projector. Large cinemas may require multiple transmitters to be covered.

The primary benefit of the system is superior image cancellation and no need for a special screen. Also, XpanD claim that light efficiency with their latest generation glasses is only surpassed by Real-D's XL system. (Initially, the light efficiency was in the 15% range, while the improved version is said to be in the 20% range.)

The core disadvantage with XpanD is that the system requires active glasses. Active technology can fail, and batteries do get depleted. With liquid crystals straight in front of the eyes, active glasses have a slight tendency to cause some diffraction blur, though the latest generation XpanD glasses provide brilliant results. Furthermore, costly as they are, the glasses have to be collected and cleaned between shows. Even though the latest generation XpanD glasses have been vastly improved compared to the early NuVision style glasses, these core disadvantages still apply. Finally, the system cannot be combined with SXRD projectors.

Cost wise, XpanD is particularly attractive for small and medium size screens.

To satisfy those customers preferring passive glasses, XpanD has also introduced a polarisation version of the system.

6.7 COLOUR TRIPLET SYSTEMS: DOLBY 3D

Dolby Laboratories has licensed the RGB colour triplet filter technology referred to as Infitec from Daimler-Chrysler (see APM Chapter 7.5.1 for further details).

Top: The Dolby 3-D wheel with two filter sectors (left and right image) is mounted inside the projector, between the light source and the light engine.

Above: Dolby has continued to provide new designs for their glasses to reduce weight and cost. Anti-theft systems are also implemented. (Dolby)

Right: Infitec wavelength triplets, one triplet for each eye.

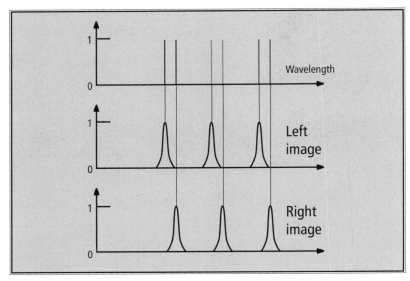

In the projector, a filter wheel is installed in the light path between the integrator rod and the light modulators. The filter wheel has a "left RGB" and "right RGB" sector, allowing the projector to project alternating frames with different RGB characteristics for the left and right eye.

The advantage with the system is that the channel separation is excellent and that no silver screen is needed. Since the separation is good, there is no need to implement ghostbusting in the playback system. Furthermore, the glasses are passive, meaning that they are less likely to fail than XpanD's re-usable ones. However, their relatively high cost means that the glasses can't be treated as disposable and they should be collected and cleaned between shows.

The core disadvantage with Dolby 3D is the very low light efficiency (only about 12% of the light output from the projector reaches the eye). While a silver screen is not required per se, a high-gain screen is often necessary to yield sufficient screen brightness (a gain of at least 1.4 to 1.8 is recommended). Another disadvantage is that there will inherently be a very slight colour difference between the left and right eye (after all, different wavelengths of light will reach the two eyes). On a well-calibrated system, the difference is very hard to spot, but calibration is critical.

While Dolby 3D could be combined with an SXRD projector from a technical standpoint (using a dual lens approach and applying some changes to the spectral response of the projector), Dolby has so far not taken the trouble to adapt its system to the Sony projectors. This means that Dolby 3D is less flexible than Real-D in terms of projector choice.

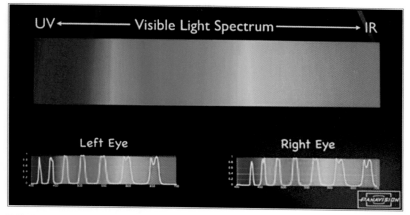

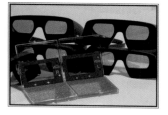

Top: 3D glasses for the Panavision process. (Panavision)

Above: Under the trade name Omega Optical Depth Defining 3D, the system is still available for the domestic market and could be applied for small screening rooms, too.

Left: The Panavision 3D system is developed jointly by Omega Optical and uses an optical comb filter to allocate seven coulour bands per image in contrast to the three bands applied by Dolby and Infitec. Illustration: Panavision

6.8 PANAVISION 3D – THE SHORT-LIVED FAVOURITE?

Panavision is one of the last entrants to the D-cinema 3-D market with their Panavision 3D System developed jointly with Omega Optical. Unfortunately, their system has recently been taken off the market. Whether this is due to lack of commercial interest or pressure from competitors is unknown. It is equally unknown if the system will be re-launched in the future.

The technology is very similar to Dolby 3D, but it has some distinct advantages. Firstly, the system is compatible with both film and digital projection. Even though the lenses and filters are different for 35mm and D-cinema, the glasses are identical. Secondly, it is the only system, other than Real-D, which is compatible with both SXRD and DLP/DMD projectors. Thirdly, Panavision claims that the light efficiency is higher than Dolby's at seventeen per cent. Panavision admits that there is no standard for defining light efficiency for 3-D projection, so whether their technology offers brighter images than Dolby in real life remains to be confirmed by independent field experience.

Due to lack of personal experience with Panavision 3D, it is premature to give conclusive advice about the system's suitability for archive cinemas. However, based on the information available, it seems to be a very strong candidate due to its versatility and its presumed high image quality. Indeed, the system's compatibility with certain old-style single-strip 3-D systems (see APM p.185), the system would have been particularly attractive for archival cinemas with aspirations to project classic 3-D films on 35mm film.

6.9 WHICH 3-D SYSTEM TO CHOOSE

Choosing a 3-D system is not the simplest of tasks, and which system is the best depends on the priorities of the operator as well as properties of the cinema or projection systems. A certain level of personal preference may also apply to those making the 3-D system purchase decision.

Even though all of the 3-D systems are capable of providing high 3-D image quality, one has to consider the following issues:

- Is 3-D image quality my core priority when selecting a 3-D system?
- To what extent do I care if my 3-D installation affects the quality of the 2-D images?
- Do I have the staffing and infrastructure to handle multi-use glasses?
- What screen size do I plan to satisfy?
- Do I have a Sony 4k projector (in which case the choice is limited to Real-D or perhaps Panavision 3D if it re-appears in the future)?

It is the author's view that screen brightness is by far the most important matter. It is of limited interest if the channel separation is good if the image is dim and little ghosting can be seen anyway. The initial de facto brightness standard for 3-D projection was as little as 3.5 foot-Lamberts, while ambitious cinema designers today seek to achieve up to 6 foot-Lamberts. Since screen brightness varies in the field, conscientious 3-D film-makers such as James Cameron have provided multiple versions of their films with different grading tailored to different screen brightness. Even so, no grading can compensate for the reduced dynamic range linked to low screen brightness. Therefore, every attempt should be made to maximise light output.

The sad fact is that the most light-efficient of the 3-D systems requires a silver screen. Due to their reflection characteristics, such screens will affect the perceived evenness of illumination. The result is that the projection quality of all films, including 2-D films, will suffer. Awareness of the problem is rising by the day, and, in France, the national film board, the CNC, is planning on introducing a standard (Afnor – Association Française de Normalisation), which practically excludes the use of silver screens to protect the integrity of the images (Variety, March 9th 2012). This measure would mean that the 1,200 silver screens in France would have to be replaced by 2017.

Columbus' egg is to install a silver roller screen in cases where the light efficiency of Real-D is required because of screen size. Such screens can be rolled up whenever 2-D films are being screened. The added benefit is that it becomes much easier to balance the light between 2-D and 3-D film presentations.

For cinemas using SXRD projectors while having screens larger than around eight metres in width, the author's choice would be Real-D in combination with a silver roller screen. For smaller screens, Panavision may be the most attractive alternative (though no personal field experience can as yet confirm this assumption, nor do we currently know if the system will re-appear on the market).

For cinemas using DLP/DMD projectors, the choice is wider, particularly if the screen is fairly small (eight metres wide or less) and the projector is powerful. From a pure image quality standpoint, XpanD, Dolby and Panavision are likely to provide the best image due to the excellent channel separation, providing that sufficient screen brightness can be achieved. All these solutions cause certain logistical challenges, particularly for large screens where the high number of glasses is both a cost and a handling issue. As the glasses wear and get scratched, diffraction in the glasses can reduce the image quality.

Of the three systems, Dolby 3D is least likely to produce a sufficiently bright picture. On a small screen, however, the system can reproduce awesome 3-D projection.

For large screen 3-D projection, Real-D and DepthQ are most likely to reach brightness minima.

The only system, which in the author's view has few other benefits than low cost, is MasterImage.

If the screen is large and the budgets are generous, dual projector 3-D could also be considered. With two projectors, the choice of options is very wide indeed, though some content providers have been sceptical about two-projector set-ups due to assumptions that two projectors are much harder to align and keep aligned. Those assuming so have probably never installed single-projector 3-D systems: they all need careful alignment and maintenance. The advantages with two projectors are plenty: excellent light output, redundancy for 2-D projection and the possibility of using a matte white screen. Also, the problem of balancing the light output between 2-D and 3-D is eliminated with two projectors.

6.10 DCPS IN 3-D

Early generation DCPs in 3-D existed in a number of versions: with or without ghostbusting, with or without subtitles – and graded for various light levels. Special ghostbusted versions are no longer required for Real-D theatres, and the Hollywood studios have sought to standardise 3-D DCPs in general, for instance through the Stereoscopic Digital Cinema Addendum, published by DCI.

A situation where "one size fits all" as far as 3-D DCPs are concerned, is still not realistic. The introduction of HFR in combination with 3-D is likely to increase the need for different versions of 3-D DCPs in the near future. And, as long as most D-cinema projectors require the sub-titles to be embedded into the image to ensure a dynamic positioning of the titles in space, each language will require its own DCP.

As far as the playback of 3-D DCPs goes, keep in mind that the colour resolution is lower in 3-D than 2-D when projected on DLP-type projectors with external media blocks due to signal transport limitations. To reduce bandwidth requirements for transmission from the server to the projector through the dual HD-SDI interface, the 4:4:4 colour resolution applied to 2-D films is reduced to 4:2:2 due to the double number of images required for 3-D (48fps). The Stereoscopic Digital Cinema Addendum Version 1.0 specifies 4:2:2, 12 bits, Y'Cx'Cz'.

On Sony SXRD projectors, the colour resolution remains at 4:4:4 since this projector is not using the time domain to differentiate between the left and right images.

Note that the reduced colour resolution is a transport matter rather than a DCP matter.

6.11 3-D AND INSUFFICIENT LIGHT LEVELS

The film creators are currently seeking to increase the illumination levels in 3-D digital cinema to go beyond 3.5 foot-Lamberts. For instance, Disney writes the following in connection with the release of their film *Cars 2*: "The light level specification for Cars 2 is 4.5 foot-Lamberts, measuring white light through the 3-D display system. The acceptable range is between 3.5fL to 5.5fL."

At the International Broadcasting Convention (IBC) in September 2012, the boundaries were pushed further with the presentation of Martin Scorsese's film *Hugo*, where the white-light luminance level reached 14fL, identical to the standard for 2-D. The light output was achieved with a prototype projection system from Christie with a laser light source, and the image quality was very well received by a rather critical audience. (Laser projection has the added benefit of a wider colour range than xenon lamp projection.)

With this in mind, it is vital to focus on brightness levels when selecting 3-D technology. But what to do if you already have a 3-D system installed and experience a dim 3-D image?

Some steps should be explored before assuming that the projection system has to be replaced:

• Install a new porthole glass. This should already have been done when you converted to digital, but many cinemas are still using glass with a light loss of more than ten per cent. If fire hardening is not legally required, use Schott Amiran Extra Clear Low Iron glass, Schott Mirogard or equivalent. (Make sure that you specify the low-iron version of the Amiran glass.) In cases where fire hardening is a legal requirement, you have two options: either use Amiran

or equivalent in combination with automatic fire shutters, or use fire-hardened glass, which depolarises the light as little as possible. Schott Pyran-S-AR or an equivalent type of anti-reflex coated and fire-hardened water-white glass works fairly well, though a tendency to depolarisation may be noted. (Make sure Pyran-S is not confused with Pyran-S-AR! Only the latter is anti-reflex coated.) Using either of these types of glass, will result in a reduction of light loss to a mere two per cent. This will benefit the image quality for all your presentations.

- If you have a Series-1 DLP projector of the old generation, you are probably running 3-D on a reduced part of the chip (hence, only part of the light cone is being used). The reason is that the old-style format boards (EFIB board) didn't have sufficient bandwidth to accept full-resolution images at the 144fps frame rate required for triple-flash 3-D. You can gain about thirty per cent more light by replacing the EFIB board with an FFIB board and reformat the 3-D preset to full resolution. You can also upgrade to a Series-2 projector to achieve the same result. A less ideal solution is to go from triple-flash to double-flash, but the disadvantage is movement artefacts, noticeable to some.

- Make sure that your projector is set up with automatic zoom presets so that the image is always as high in resolution and as high in brightness as it can get (for fixed image height screens). Many set-ups only utilise 858 pixels for both CinemaScope and widescreen 1.85:1, wasting resolution and brightness in the widescreen format.

- Consider using an anamorphic lens if your brightness problem is only noticeable in CinemaScope (for fixed image height screens).

- Install a higher wattage lamp or a high brightness version of the same wattage if it is available for your projector.

- Install a high gain screen (1.4 or 1.8) if you are currently using a matte white screen. Unless the screen is curved, this should be a roller screen to prevent the 2-D image quality being compromised. To harmonise brightness levels between 2-D and 3-D, a roller screen is always the preferred approach.

If none of the above leads to satisfactory results, you will have to re-consider your entire set-up. You may opt for a more light efficient 3-D system, a more powerful projector or a dual projector set-up.

6.12 EXCESSIVE LIGHT OUTPUT IN 2-D

It is a common problem with 3-D projection systems that the image will be too bright in 2-D because the lamp cannot be turned down sufficiently. (Xenon lamps will not burn steadily on too low a current.)

The best way to address this problem is to use a high gain roller screen in 3-D (silver screen if polarisation systems are utilised) and a matte white screen in 2-D. This solution is beneficial also if a non-polarisation system is used since it will make it far more likely that sufficient screen brightness is reached, even when the xenon bulb is not new.

A similarly good solution is to install dual projector 3-D, though cost will often prohibit this approach.

The low-budget solutions to the problem are far from ideal. The most intuitive and cost effective solution is to change the lamp between 2-D shows and 3-D shows. However, this requires a skilled projectionist and ample time between shows.

Another option used in the field is to defocus the lamp in 2-D, something which drops the light output. However, it requires some skill to do this, and one may cause heat damage to the projection system. Some manufacturers may prohibit this practice, which may cause the warranty to be void.

Theoretically, a good option would be to install a variable iris in the projection lens. Schneider Optics did provide projection lenses for 35mm with this feature (Schneider Premiere), and one would think that the same should be possible with D-cinema lenses. A skilled cinema engineer with good optical knowledge may be capable of customising such a system.

Another attractive option would be to install a small aperture in the optical path of the projector. Some DLP projector manufacturers provide such apertures for preview theatre projectors, and if they could be actuated by electro-mechanic means, the light balancing could even be automated.

Finally, it is possible to mount neutral density filters in front of the projector lens.

It does however seem rather wasteful to run 2-D films consistently with higher wattage than needed, so the two-projector or roller screen option comes across as being far more attractive.

CHAPTER 7 **SOUND FOR DIGITAL CINEMA**

7.0 D-CINEMA AUDIO

As mentioned in Chapter 4.7, the sound specification for D-cinema is quite straightforward. Twenty-four bits of audio sampled 48,000 or 96,000 times per second provides an excellent format for audio of the highest quality. Since the audio is entirely uncompressed, the need for a dedicated cinema sound decoder is gone. At least this was the case until extended surround systems and other enhanced channel layouts were introduced. But just as 3-D appeared to increase the visual impact of D-cinema, enhanced audio systems were also launched – though so far adapted to a much lower degree in the market than stereoscopic 3-D.

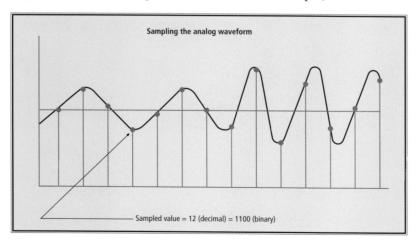

Sampling the analog waveform

Sampled value = 12 (decimal) = 1100 (binary)

Audio sampling – here 14 samples are shown, and the samples are taken too infrequently to accomplish a good representation of the analogue waveform. D-cinema audio, on the contrary, is sampled 48,000 or 96,000 times per second, ensuring very exact audio reproduction, even at the highest audible frequencies.

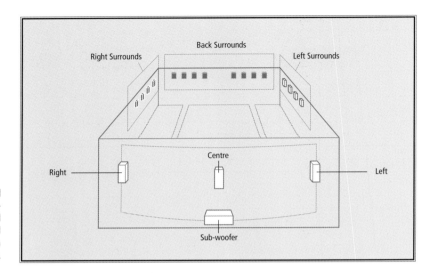

6.1 audio with a single rear surround channel. This layout is getting increasingly uncommon as it is being replaced by the 7.1 format with four surround channels (the rear wall is divided in a left and a right section).

7.1 EXTENDED SURROUND SYSTEMS

As one will see, the basic soundtrack layout of the DCI specification does not include extended surround (refer to the APM pp 133-134 for further details about extended surround). However, a number of digital films are mixed with more than two surround channels. The most common concepts are either 6.1 (with a rear surround channel in addition to left and right) or 7.1 (with four surround channels in total, two on the rear wall and two on the side wall).

The 6.1-concept utilises matrix encoding/decoding to pack three channels into two. In other words, the channel layout of the file format and through the D-cinema server stays at two surround channels, while external sound processors bring out the third surround channel (rear surround).

Existing 5.1 audio channel layout

Audio Channel	Analog Channel Number	Server AES Output Pair	Cinema Processor AES Input Pair
L	1	1	1
R	2		
C	3	2	2
LFE	4		
Ls	5	3	3
Rs	6		
HI[1]	7	4	4
VI-N (AD)[1]	8		

The 5.1 track layout of a standard DCP. (Dolby)

[1] These channels are not provided in all territories.

New 7.1 audio channel layout

Audio Channel	Analog Channel Number	Server AES Output Pair	Cinema Processor AES Input Pair
L	1	1	1
R	2		
C	3	2	2
LFE (SW)	4		
Ls	5	3	3
Rs	6		
HI[1]	7	4	–
VI-N (AD)[1]	8		
–	9	5	–
–	10		
Bsl	11	6	4
Bsr	12		
–	13	7	–
–	14		
HI[2]	15	8	–
VI-N (AD)[2]	16		

The channel assignment is about to change, as Dolby moves towards the 7.1 channel configuration. (Dolby)

[1] These channels are not provided in all territories. In order to maintain compatibility with existing installations, Audio Description will be provided on channels 7/8 for initial Dolby Surround 7.1 releases in territories where this is current practice.

[2] Similarly, not all territories provide these channels. In order to maintain compatibility with forthcoming channels allocation standars, HI/VI-N audio may additionally be provided on channels 15/16.

Utilising such external sound processing equipment when we deal with a digital film format with free audio tracks makes little sense, so the 7.1 concept is superior in that all four surround channels are fully discrete, being transported as linear PCM (Pulse Code Modulation) audio through the system. And while 6.1 as currently implemented in the field requires some kind of proprietary audio processing performing the matrix decoding, any sound processor with a sufficient number of channels and routing options could play back 7.1-audio. It is an open concept – free for all to exploit.

Under the trade mark Dolby Surround 7.1, *Toy Story 3* (2010) is recognised as the first film in the format.

7.2 AURO-3D

As a response to the initial popularity of digital 3-D stereoscopic films, various cinema technologists argued that the sound should also provide a more realistic and three-dimensional experience than current multi-channel audio systems. However, a more immersive sound experience meant a significantly higher number of playback channels than the DCI channel layout would allow – at least with conventional speaker designs.

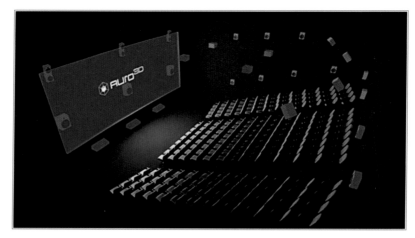

Auro-3D exists in a number of channel layouts, most commonly 11.1 or 13.1. (Auro-3D)

The Belgian company Auro Technologies, which has its roots in Galaxy Studios, found a solution to the problem by introducing its own Auro-3D Octopus codec to D-cinema. Basically, Auro Technologies pointed out that 24 bits per sample is somehow "excessive" in a cinema listening environment due to the fairly high noise floor at one end and the loudness limitations at the other end (see Chapter 3 on sound) and that the extra available bits could be used to pack a high number of audio channels into a transport stream of fewer channels. For instance, it is possible to pack 11.1 channels into the standard 5.1 channels of a DCP. Auro's 3-D sound, or Aurophonic multi-channel sound as the company calls it, can have any number of channels between ten and 24. Important to the concept are high-mounted speakers, providing a third axis to the sound experience. This is in contrast with the IOSONO system, which uses only a single row of speakers.

The benefit of Auro's codec is that it is based on normal uncompressed digital audio (linear PCM), and a DCP with an aurophonic sound mix is therefore fully compatible with cinemas running standard 5.1 or 7.1 sound. The codec is virtually lossless, and no perceptual coding techniques are used (unlike Dolby AC-3, MP3 etc). Crucial to the system is the super-fast audio processor, which is capable of doing the decoding with a delay of only three samples. Thanks to this, lip sync is not affected. (*Auro-3D Octopus codec – Principles behind a revolutionary codec*, van Daele / van Baelen, Belgium, 2011).

In D-cinema applications, the standard Auro-3D channel layout is 9.1, 10.1, 11.1, 12.1 or 13.1, depending on whether the DCP has a basic channel configuration of 5.1 or 7.1. The channel configurations include at least two extra stage channels (with an option for three), positioned above the conventional left, right and centre channels. Additionally, there are extra high-mounted surround channels in various configurations – and the option of a top speaker, commonly referred to as "the voice of God".

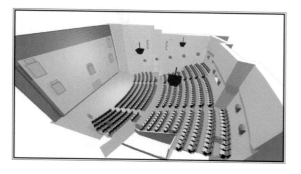 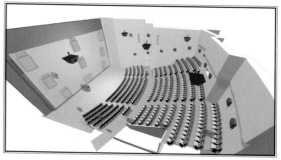

A special proprietary audio processor is required, the Auro 11.1, brought to market by Barco, the D-cinema projector manufacturer. The Auro 11.1 processor also has inputs for other external sources and can in some cases replace a standard cinema audio processor.

Imm Sound is not a channel-specific sound format, but the company has suggested two configurations, 14.1 and 23.1 (Imm Sound)

Lucasfilm's *Red Tails* (2011) was the first feature film to be released in cinemas with an Auro 11.1 sound track.

7.3 IMM SOUND

Since the early days of spatial sound recording and reproduction, sound systems have been designed around a certain number of playback channels – from two-channel stereo to multi-channel 5.1-audio. Imm sound – a Spanish company established in 2010 – has built on research done by the company Barcelona Media and launched an entirely new approach to cinema audio through its channel-free approach.

Instead of preparing an audio track based on a number of channels, the audio is recorded with an assigned position in a three-dimensional space. The user interface in the post-production process is a joystick, which positions the sound to the desired location.

The purpose of the Imm sound cinema processor is to output the recorded 3-D sound in such a manner that each individual sound element will appear to be at the same position in the auditorium as it was assigned to during the recording or mastering session. The sound processor will use whatever channel count and channel layout the cinema has to accomplish this goal.

Needless to say, the more channels present in the playback chain, the more precise the sound localisation can be. Imm sound recommends not fewer than three overhead ceiling channels as well as independent surround channels instead of diffuse surround concepts where one channel is assigned to a large number of speakers. Suggested layouts include 14.1 and 23.1 channels, but the system is also compatible with existing 5.1 layouts. (*Immersive 3D sound for cinema*, Mateos,

López and Artigas, Barcelona, 2011.) In either case, a special Imm sound processor is required. The sound processor can also do the reverse job – i.e. make a standard 5.1 audio track sound as if it is being played back from a typical 5.1 audio system, even though it is being played through an Imm sound system.

The first feature film announced to be released in the Imm sound format is *The Impossible* (October 2012).

Their competitor, Dolby, acquired Imm sound in July 2012, and it is expected that the Imm sound technology will be merged entirely with Dolby Atmos.

7.4 DOLBY ATMOS

Dolby Atmos is a new sound concept conceived by Dolby to compete with innovations such as Auro-3D and IOSONO. Dolby Atmos combines a standard 5.1 or 7.1 channel audio package with an additional audio stream for the complex Dolby Atmos mix, which can yield up to 128 channels of audio tracks routed to up to 64 speaker/amplifier outputs in the theatre.

Crucial to the concept is the addition of sounds originating overhead and from discrete sources throughout the auditorium to create a more immersive sound experience.

To play back a Dolby Atmos film, extra speaker systems must be installed on the walls and in the ceiling of the cinema, and Dolby recommends adding two stage channels in larger theatres, Left Centre and Right Centre, to ensure smoother pans and more accurate placement of sound in relation to the image.

In the mixing process, Dolby distinguishes between "beds" and "objects". With beds, Dolby refers to a complete sound mix for a particular channel in a multi-channel system. In other words, beds are equivalent to a sum of "stems" used for 5.1 and 7.1 audio today (a stem is an isolated element of a sound mix with either dialogue, effects or music). "Objects", on the other hand, are single sounds routed to a specific location in the auditorium. Depending on the loudness requirement of the object, Dolby Atmos mixes will either send a single object to a single speaker, or to a combination of speakers.

With the channel configuration of Dolby Atmos, Dolby re-introduces a channel layout of five stage channels despite having left the two extra stage channels unused since the mid 1970-ies. (Dolby)

Dolby Atmos films are fully backwards-compatible with conventional audio systems; The 5.1 and 7.1 packages are played back conventionally as linear PCM over the AES/EBU outputs on the server, utilising the conventional DCI channel assignment. The extra audio channels, however, are routed from the server to the proprietary cinema sound processor over network. This means that 9.1 audio with the two extra stage channels – when included in an Atmos film – also requires the use of the special Dolby Atmos playback system, even though DCI has specified channel assignments for the Left Centre and Right Centre channels in the conventional audio package.

Demonstrations of the system have been well received at trade shows.

Traditionally, Dolby has been rather conservative with regard to channel count and speaker positions. Indeed, they were keen to emphasise the importance of preventing surround sound in the cinema from distracting from the action on screen. As late as 1991, ceiling-mounted surround speakers were claimed to be of little use by Dolby, due to their non-uniform coverage. Dolby also argued that very few sounds in real life come from above people's heads, making ceiling speakers of little relevance – and potentially distracting (*Matching the Sound to the Picture*, Ioan Allen, Dolby Laboratories, 1991).

Twenty years later, Dolby sees it differently: "In the real world, sounds originate from all directions, not from a single horizontal plane. An added sense of realism can be achieved if sound can be heard from overhead, from the 'upper hemisphere'. The first example is of a static overhead sound, such as an insect chirping in a tree in a jungle scene. In this case, placing that sound overhead can subtly immerse the audience in the scene without distracting from the action on the screen." (*Dolby Atmos, Next-Generation Audio for Cinema*, Dolby, 2012.)

Not only that, Dolby now claims that room-centric audio will better support the on-screen action.

Until the introduction of Atmos, Dolby was also opposed to more than three

Dolby's white papers "Matching the Sound to the Picture" (Ioan Allen 1991) and "Dolby Atmos – Next-generation Audio for Cinema" (2012) present opposite conclusions with regard to ceiling surround as well as five stage channels. (Dolby)

stage channels (plus a low frequency effects channel) behind the screen. The company decided to omit the Left Centre and Right Centre channels from 70mm film sound back in the 1970-ies, leaving cinemas with three stage speakers: Left, Centre and Right.

Hazard E Reeves, who invented the Cinerama sound system in 1952, settled for five stage channels, claiming that this was the smallest number of speakers he could use to achieve a good stereophonic effect. With fewer speakers, noticeable holes in the sound would appear. (*Adding the Sound to Cinerama*, Hazard E. Reeves, 1953.)

With the introduction of Todd-AO three years later, the same channel configuration of five stage channels was kept for the very same reason.

Later, the Russian film sound expert Michael Z. Wysotsky performed research showing that the stereophonic effect increases only until a maximum of five channels – adding more speakers will not give any noticeable extra benefit. (*Wide-Screen Cinema and Stereophonic Sound*, Wysotsky, London/New York, 1971.)

When Dolby decided to omit two of the stage channels, their stated reason was that theatres had become so much smaller that no "holes" in the sound could be detected anymore. It was also claimed that the need for extra channels to fill "the two holes behind the screen" was much smaller, as the "phantom channel" phenomenon would be more present in modern theatres due to supposedly better loudspeaker matching after the introduction of room EQ and better damped room acoustics. By 1991, Dolby claimed that the number of theatres with screens wide enough to justify a five-channel system most likely numbered no more than a handful. (*Matching the Sound to the Picture*, Ioan Allen, Dolby Laboratories, 1991).

Nonetheless, by 1997, there were more than 500 cinemas in the world equipped with five front channels following the introduction of Sony's SDDS (Sony Dynamic Digital Sound), a 35mm digital sound film format. (*The Eight Channel Advantage*, John F Allen, Boxoffice, 1997.)

SDDS had the benefit of five stage speakers, re-introducing the 70mm channel configuration. Dolby continued to argue fiercely against the "8-channel advantage", however, most likely because Dolby Digital was only capable of reproducing three stage channels – and then only with significant compression.

In the Dolby Atmos White Paper, Dolby has shifted its stance: "As we have studied the perception of elevation in the screen plane, we have found that additional speakers behind the screen, such as Left Centre (LC) and Right Centre (RC)

Above: With wave-field synthesis (WFS), a number of small sound sources are recreating the single sound wave from another source positioned at a different location in space. Illustration: IOSONO

Left: At the IOSONO sound lab the Fraunhofer Institute for Digital Media carries out research in the field of spatial audio rendering technologies. The technology has been brought into the cinema sphere, and the speaker layout in commercial IOSONO cinemas is basically the same as the one used at the lab. (Fraunhofer Institute)

screen speakers (in the locations of Left Extra and Right Extra channels in 70mm film formats), can be beneficial in creating smoother pans across the screen. Consequently, we recommend installation of these additional speakers, particularly in auditoria with screens greater than 12m (40ft) wide."

While it remains to be seen how widespread the use of overhead surrounds will be, there is no doubt that five front channels have a significant positive impact for archival cinemas. This channel layout is required to play back films with five front channel mixes correctly, whether it is a matter of 70mm films from the 1950s or 1960s, mainstream Hollywood content from the 1990s or current Dolby Atmos films. Furthermore, with five front channels and a suitable audio processor/signal router, the inner and outer channels can be used independently for three front channel mixes, adapting the audio to the image. A CinemaScope film will then use the outer left/right channels and a flat film can be played back through the inner channels. This feature is relevant for cinemas operating with a fixed image height, particularly for films in the Academy ratio. Finally, two extra stage speakers provide a good level of redundancy for all three-channel films.

Dolby's note on linking the five stage channel option to screens wider than0 12m makes little sense, though. Just as the 4k resolution advantage is linked to the subtended angle rather than the absolute screen width, the five-channel advantage will depend on the relative screen width – or rather the relative screen speaker separation.

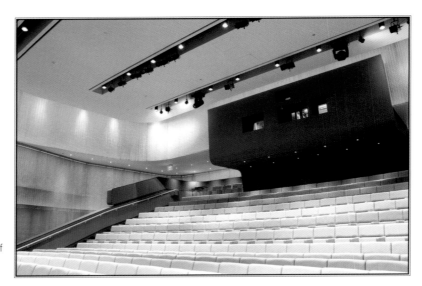

At the Peltz Theatre in Beverly Hills, the interior design elegantly hides the array of IOSONO speakers.
(Iosono)

7.5 IOSONO
While Auro-3D and Atmos are aimed at providing a third dimension by adding a third axis with high mounted speakers following a multi-channel approach, IOSONO has created a system with two distinct goals:

- Increasing the size of the sweet spot in the auditorium, making sure that more patrons than those in the middle few seats have the benefit of an uncompromised sound experience when 5.1 or 7.1 mixes are being played back.
- The possibility of positioning the sound at an exact position in the auditorium by taking the full advantage of the wave-field synthesis (WFS) approach, which is key to the IOSONO technology. The precision is remarkably high, and in fact the sound can be mixed so that when a particular object is seen to travel from one direction to another across the screen, the sound appears to pass through the heads of the patrons.

WFS is a way of reproducing sound, which attempts to recreate the physical attributes of a spatial sound field in contrast to stereophonic multi-channel sound, which relies on psycho-acoustics and "phantom sound sources".

Simplified, this is how WFS works. Imagine that you are in a tent with perforated walls. It is possible to localise most sound sources outside the tent in the spatial domain, even though the original sound waves have been broken up as they pass through the perforations. This happens because the "broken" sound waves recombine as the original sound wave inside the tent, according to the Huygens principle.

In a cinema, WFS is accomplished by installing a large number of speakers in a line going around all four walls of the room. This continuous line of sound sources can be compared to one continuous line of perforation holes at ear height in our tent. Since all speakers are connected to individual amplifiers and sound channels from the sound processor, one can imagine that any single sound location could be reproduced by making sure that each speaker is fed with the right fraction of the elementary wave, which in turn will recombine as the "original" recorded, or, rather, synthesised, wave.

To be able to create a fully realistic sound field, a special mix has to be created, typically with 128 channels. However, standard 5.1 and 7.1 mixes will also be played back in an improved manner. As mentioned, this is due to the fact that the sweet spot is enlarged. Again, imagine the size of the sweet spot which would normally include only a couple of seats in a small home theatre. As most cinema technicians have experienced, the larger the cinema, the more seats will fall in the sweet spot. If we imagine a room that is infinitely large, in theory almost all seats will be in the sweet spot. Thanks to WFS, it is possible to create the illusion that the 5.1/7.1 speakers are positioned way outside the cinema, ensuring that the entire seating area ends up being in the sweet spot. Therefore, even a standard sound mix will benefit from an IOSONO installation.

IOSONO has launched a spatial audio processor, IPC 100, which can carry 64 input channels and 128 output channels. For very large venues requiring a larger number of speakers, more IPC units can be connected in parallel.

IOSONO was first introduced by the Fraunhofer Institute and IOSONO GmbH in Germany in 2004, and the first film released in the system was *Immortal Beloved* (2009).

7.6 D-CINEMA SOUND PROCESSORS

Installing D-cinema requires a proper review of the cinema sound system. Even though the baseline 5.1 channel configuration is compatible with your existing 5.1 sound system for 35mm film, there are, in many cases, good reasons to re-design the audio processing chain.

If you already have a sound processor installed with digital multi-channel audio inputs (8-channel AES/EBU format) – such as the Dolby CP650 – you may indeed connect the server directly to this input. If the processor does not already support the AES/EBU format, it is sometimes possible to upgrade the processor with an additional circuit board (for instance upgrading a CP650D to CP650). In many installations, there is, however, sound processing equipment between the power amplifier and the sound processor (e.g., digital crossover networks),

Norway, the world's first entirely D-cinema equipped country rolled out with the Yamaha DME-64 audio processor. It is extremely versatile and has four slots for input and output cards. The ins and outs can be multi-channel symmetrical analogue audio, AES/EBU digital audio, networked audio (CobraNet / EtherSound) or MADI (see the photo above), to mention a few of the interfaces. 64 channels can be handled simultaneously. (Yamaha)

which perform an entirely unnecessary analogue-to-digital and digital-to-analogue audio conversion. In other installations, the central cinema processor has no digital audio input (Dolby CP500/CP65, Sony DFP-D3000, etc.) and requires an external digital-to-analogue converter in addition to the existing processor. In both cases, it makes sense to re-think the processing layout by installing a new central audio processor, which becomes the only processing unit between the output of the D-cinema playback server and the input of the power amplifiers. Such a clean signal path simplifies audio alignment, it reduces the number of error sources, and it can sometimes improve the audio quality. The existing sound processor for 35mm and 70mm film playback should be kept and routed to a multi-channel analogue input of the new central sound processor.

Since no particular cinema sound decoding is required, there is a tremendous selection of possible audio processors on the market capable of doing the job. Keep in mind, though, that a sound processor specifically designed for cinema purposes tends to be substantially easier to set up in a cinema environment. In other words, going for a generic audio processor requires access to very skilled cinema engineers, who know how to integrate such products correctly.

Norway, the world's first fully digitised country, rolled out D-cinema with the Yamaha DME-64 as the core digital audio processor. It is a very flexible unit, which can be configured with a number of different analogue and digital inputs,

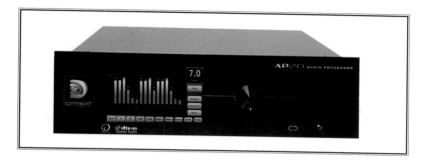

The Datasat AP20 is one of the most versatile sound processors for D-cinema. It includes four HDMI inputs, and since the unit also has an HDMI output, it can also act as an image signal switcher for alternative content. Another plus is that the unit can be delivered with the option of playback of optical analogue sound with A and SR type noise reduction. (Datasat)

and the task of tailoring different EQ settings is a breeze. The processor can also be supplied with network audio interface cards for CobraNet or EtherSound. The high reliability of the unit, as well as its superb audio quality, makes it a perfect choice for an archival cinema. However, it requires training to set it up correctly, and it is less foolproof than standard cinema audio processors.

Another attractive choice is the Datasat AP20 processor. With sixteen channels of digital and analogue audio inputs and outputs, this cinema-specific audio processor delivers 85 input options and 34 output options. Most importantly for archival cinemas, the unit includes four HDMI inputs for players of alternative content. It is perhaps the most versatile cinema audio processor available on the market today.

For those who prefer the Dolby line of processors, the CP750 is one option. However, except for unique support for the various versions of extended surround systems, the inclusion of pro-logic decoding of external sources, as well as seamless integration with other Dolby D-cinema products, the processor has very few advantages for an archival cinema over the Datasat AP20 or the Yamaha DME-64.

A recent addition to Dolby's line of cinema processors is the CP850, which is designed as a core cinema processor as well as being capable of reproducing

Above: The Dolby CP850 processor, supporting Dolby Atmos. (Dolby)

Right: The QSC DCP-300 does not include the same amount of archive-relevant features as the Yamaha DME-64 or the AP20, but it is easier to set up than the Yamaha DME. (QSC)

Dolby Atmos tracks. The unit is equipped with an automated calibration feature for B-chain alignment of the audio system, but it has not yet been confirmed whether this can replace an audio calibration session with a well-trained cinema audio engineer.

The CP850 processor introduces yet another proprietary Dolby technology – Dolby Atmos Connect, which is Dolby's sound-over-ethernet protocol used to distribute audio to the various Atmos channels. For cinemas using legacy amplifiers to feed these extra channels, a separate audio converter is required, the DAC3201.

If you intend to distribute audio over network using CobraNet – a well-established sound-over-ethernet protocol, QSC's processor DCP-300 is an alternative, as it has CobraNet connectivity built into the processor. The processor does not, however, quite match the versatility of the Yamaha DME-64 or the Datasat AP20. Also, it does not support Dolby Atmos on its own. On the other hand, it is significantly easier to set up than the competing CobraNet option from Yamaha.

7.7 CINEMA AUDIO REQUIREMENTS

With 24 bits of resolution, the theoretical dynamic range of D-cinema audio is vast. However, the playback norms still conform to SMPTE 202M, meaning that the peak signal per stage channel is 105dBC. The noise floor in the cinema represents the other end of the scale, meaning that the practical dynamic range is the same as it was for digital sound on 35mm film. From that point of view, one may assume that there is little need to upgrade speakers and amplifiers just because D-cinema has been introduced.

Having said that, the frequency restrictions associated with certain 35mm

film-based digital sound formats are history with D-cinema, and the clean and uncompressed nature of D-cinema sound will only be fully appreciated by the audience if high-quality components have been chosen throughout the entire audio playback chain.

Refer to Chapter 2.5.6 and 2.5.7 in the APM for further details about selecting suitable power amplifiers and loudspeakers. The advice is still valid, though extended surround and 3-D sound technologies may require special speaker and amplifier layouts.

CHAPTER 8 **D-CINEMA IN THE BOOTH**

8.0 INTRODUCTION

Assuming that your cinema has been appropriately D-cinema equipped by a qualified engineer, it is now time to do the last preparations for digital screenings. Even though D-cinema is marketed as a technology providing more flexibility and simpler operation than its analogue counterparts, you will soon encounter new hurdles.

In the author's experience, the two most challenging aspects with D-cinema are linked to key management and ingest time. The beauty of a 35mm film print is that it can be played some five minutes after it has reached the booth (if the cinema is equipped with a reel-to-reel change-over set-up). Once you have the print in hand, you are more or less safe.

With D-cinema, on the contrary, you may well receive the DCP in time for a show, but this is of little help if you haven't got the KDM, if the KDM has expired, if it is not yet valid or if you haven't got time to ingest the DCP.

For archival cinemas with a large number of films on the programme, an added challenge is storage space. As DCPs expand in size due to 3-D, high resolution or high frame rates, the playback servers are rarely capable of keeping a large number of films ingested. Instead, the external TMS stores the DCPs and performs the ingest process at the required time. The ingest speed from the TMS to the playback server will depend on a number of parameters, such as the cinema network speed and the characteristics of the hardware used. Unfortunately, the

ingest speed does not currently match the lacing speed of a 35mm film projectionist. This is something the programming department has to factor in when going digital.

8.1 PROJECTOR MACROS

The digital projector will be configured with presets known as macros. A projector macro is a package of preset parameters, which governs aspects such as lens position, colour space, input choice, output current from the xenon lamp rectifier, masking/blanking etc.

While projection set-ups in commercial theatres may only include a handful of macros, an archival cinema would normally require a large number of macros to cater for all the various aspect ratios used. Below you will find a few relevant macros, assuming a fixed image height:

- DC 2.39 – Playback of SMPTE DCPs with XYZ colour space, aspect ratio 2.39:1.
- DC 1.85 – Playback of SMPTE DCPs with XYZ colour space, aspect ratio 1.85:1 (and potentially also 1.78:1, 1.66:1, 1.37:1, 1.33:1 and1.19:1, unless various vertical blanking is required, in which case five additional macros are needed).
- DC 2.21 – Playback of SMPTE DCPs with XYZ colour space, aspect ratio 2.21:1 (for restored films in the 70mm format).
- DC 2.76 – Playback of SMPTE DCPs with XYZ colour space, aspect ratio 2.76:1 (for restored films in the Ultra Panavision 70 format).
- HD 2.39 – Playback of HD DCPs in the 2.39:1 aspect ratio, utilising the 1920 x 1080 container (803 x 1920 pixels). This ratio may be associated with a limited colour space, such as ITU rec 709, but today more and more DCP providers use the XYZ space. Ideally, HD macros for both XYZ and rec 709 should be configured.
- HD 1.85 – Playback HD DCPs in the 1.85:1 aspect ratio (1038 x 1920 pixels). Colour space: as HD 2.39.
- HD 1.78 – Playback HD DCPs in the 1.78:1 aspect ratio (1080 x 1920 pixels). Colour space: as HD 2.39.
- 3-D 2.39 – Playback of 3-D DCPs with aspect ratio 2.39:1, the colour space will depend on the 3-D system used.
- 3-D 1.85 – Playback of 3-D DCPs with aspect ratio 1.85:1, the colour space will depend on the 3-D system used.
- AC 2.39 – Alternative content with aspect ratio 2.39:1, normally the DVI input is used and the ITU rec 709 colour space is applied.
- AC 1.85 – Alternative content with aspect ratio 1.85:1, normally the DVI input is used and the ITU rec 709 colour space is applied. Unless various vertical blanking is required, this macro can also be used for films in less wide aspect ratios (1.78:1, 1.66:1, 1.37:1, 1.33:1, 1.19:1)

- VGA 1.78 – For external computer connections, preferably via an external scaler. The aspect ratio will depend on the setting of the computer graphics card, but the 16:9 / 1.78:1 ratio is a good starting point, since it is supported by most computers. The colour space will depend on the computer settings, too (for instance RGB or YPbPr, see APM p.259).

8.2 DCP INGEST AND VALIDATION

"There is a lot of bandwidth in a truck." So goes a saying in the D-cinema sphere, explaining why DCPs are still being shipped on physical storage discs from the distributor to the cinema. Trucks can reach virtually any location at a low cost, while high-bandwidth internet connections cannot quite yet.

Even though satellite transmission is already in limited use for film distribution, the cost and complexity has so far meant that the physical hard-drives are still the dominant distribution platform.

The hard drives used normally belong to the distribution company or its DCP distribution contractor. In other words, once the film has been ingested into the server, it is commonly expected that the drives will be shipped back. For redundancy purposes, it makes sense to ensure that the DCP is stored on at least two different storage systems before the drive is returned, for instance on the local playback server as well as the central TMS. Even though redundancy is built into both the server and the TMS as a matter of default, experience indicates that keeping the content stored on two different systems makes sense.

The hard drives will be equipped with at least a USB port for ingest purposes, but it is increasingly common to find external eSATA connections, providing a faster ingest speed (currently 3,000 or 6,000Mbits/sec compared to 480Mbits/sec for USB 2.0). Some TMS systems also accept direct mounting of CRU-dataport products with eSATA interface, something that simplifies DCP ingest further.

The ingest speed will depend on a number of factors, such as the port type used, the bus speed of the system and, obviously, the size of the file. A typical feature-length DCP with a file size of 160GB will take approximately two hours to ingest over USB 2.0, whereas eSATA ingest of the same file can take as little as half an hour.

Some playback servers support playback-ingest, meaning that the film can be played back while it ingests. The ingesting will have to start some fifteen minutes before the show begins.

A new complication occurs as D-cinema moves from the current and past Interop-DCPs to the standardised SMPTE DCPs. The latter type of DCPs are

required to be validated after ingest, a process which can take anything from three to forty-five minutes. Some D-cinema system providers are offering workarounds, meaning that validation in one screen will be accepted as a validation in another screen of the same cinema complex.

8.3 PREPARING YOUR OWN DCP HARD DRIVE

Even though bandwidth limitations still make film distribution over network a slightly unusual phenomenon, as previously emphasised, shorter films such as trailers are often made available online. Archival cinemas are currently unlikely to be connected to automated content delivery systems over network, where films are transferred automatically from a central distribution server to the TMS in the cinema. In other words, some kind of hybrid solution, where a physical disc may be involved, should be expected in the short to medium term.

When DCPs are provided online on a simple repository, the projectionist will normally have to download the file and store it on an external storage medium before ingesting it into the D-cinema system.

In other cases, the cinema may want to store a physically delivered DCP on a separate storage system other than the TMS, before putting it back on a hard drive and ingesting it into the D-cinema system.

Another conceivable scenario is that the film archive is preparing its own DCPs and wants to ingest them into the D-cinema system without having a direct network interface to the playback server.

In all of these cases, the projectionist will have to prepare his or her own DCP disc. It is therefore important to be aware that not all playback servers and TMS-units will accept any kind of disc formatting. To ensure compatibility with all D-cinema devices in the field, avoid file structures such as FAT-32 (File Allocation Table 32), NTFS (New Technology File System) or Mac OS Extended. Instead, format the discs in the Ext2 format (second extended file system for the Linux operating system) before putting the DCP on the disc. The more modern Ext3 file system could also be used in some cases, but only the Ext2 format provides the desired multi-platform compatibility.

Also, contemporary Ext2 with its default 256-byte-sized inodes is not accepted by all systems – therefore choosing an inode size of 128 byte is the safest approach.

If you are using a Windows computer to format the disc to Ext2, you may need to install an application such as FS driver (http://www.fs-driver.org).

After copying the DCP, make sure that all bits are actually copied. A couple of

missing bits may not be enough to stop the DCP from ingesting, but it is still very likely to cause playback problems.

If the DCP is received through file transfer over FTP (File Transfer Protocol), it is recommended to utilise binary transfer type rather than the ASCII or Auto settings.

8.4 ALTERNATIVE CONTENT

Alternative content (AC) is a term used for content in any other format than the D-cinema format. AC could, for instance, refer to live satellite transmissions, external laptop connections, playback of BluRay discs or HDCAM tapes, etc.

Chapter 9 of the APM includes a thorough description of AC formats, referred to as "electronic cinema".

Common to all these formats is the fact that they are inherently more un-predictable than DCPs when it comes to aspect ratio, frame rate, colour space, image and sound quality, copyright-region limitations, playability, etc. Conse-quently, it is highly recommended to try to get access to DCPs whenever pos-sible.

If DCPs cannot be obtained, an alternative path could be to create your own DCP of the supplied material, providing you have the equipment, software and skill to do so – and that you have the approval of the content owner.

The art of creating your own DCP is a topic for a separate publication, but relevant software platforms include Fraunhofer's Easy-DCP, the open-source OpenDCP as well as DCP plug-ins for Apple Final Cut Pro provided by compa-nies such as Doremi and Qube.

If the DCP path is not possible with the chosen content, external computers or players are required. In addition to a high-quality computer with a potent gra-phics card, you will typically need a BluRay player and an HDCAM / HDCAM SR deck (see APM Chapter 9.5 for further details).

The BluRay player should offer compatibility with as many disc types as possible, and it should be possible to disable on-screen display messages (OSD).

Most importantly, a capable video scaler and source selector is required. To offer seamless shows, a video scaler with a separate image preview output is a big plus.

The selection of such units is huge, but some products stand out as tried and tested for this type of application:

- Barco DCS-200 (HD/2k)
- Barco ImagePro-II (up to 4k)
- Calibre PVPro HD-DC (HD/2k)
- Extron System 7SC (HD)

With the introduction of built-in media blocks in D-Cinema DLP projectors, further options include using the media block as an external image processor and source selector, such as the Barco IMS-1000 Integrated Media Server.

Also, some projector manufacturers provide dedicated D-cinema source selectors and video processors:

- NEC MM3000 MultiMedia Switcher
- Christie SKA-3D (includes sound processing)

However, such integrated image processing equipment provided by the projector manufacturers are rarely equipped with an image preview output.

When playing back alternative content, be aware that the image processing in the projector takes some time and that the audio may have to be delayed to avoid poor lip-sync performance. A delay of approximately two frames is common. Additionally, the scaler will add further delay. Preparing audio processor macros with dealys ranging from zero to 160 milliseconds provides the required flexibility.

Also, the jungle of sound formats for alternative content is a challenge. Dedicated audio processors such as the Datasat AP20 and the Christie SKA-3D are helpful tools.

8.5 MAINTENANCE
Maintenance of D-cinema equipment is normally covered in a service agreement between the cinema and the integrator, at least if the equipment is covered by an extended warranty plan.

As a minimum, the contracted integrator should do a thorough calibration of the entire projection system, including full projector colour calibration and software update, at least once a year. For SXRD projectors, the colour calibration session may also be required to including colour-shading compensation with the Sony PCAT (Projection Calibration Tool).

The extent to which the projectionist is supposed to perform maintenance tasks will depend on the service level agreement (SLA). Generally speaking, though,

the projectionist will normally be expected to take care of surface cleaning as well as bulb and air filter replacements between each yearly overhaul.

Additionally, the projectionist should monitor the image and sound quality carefully during all shows.

Furthermore, it is highly recommended to run test films on a regular basis, for instance bi-weekly and prior to any premiers, test screenings and other critical projection sessions.

Recommended test DCPs include:

- The Stem (SMPTE) – subjective test film
- Dolby audio level test (Dolby) – provides reference audio levels at 85dBC for each stage channel, etc
- White level illumination test – provides reference white level, which should measure 48cd/m² (14f-L) regardless of aspect ratio

A luminance meter should be used to test the brightness, whereas an SPL meter should be used to verify the sound pressure levels.

The most commonly found imperfections during D-cinema screenings include incorrect playback levels, incorrect luminance levels, as well as incorrectly configured projector macros (wrong lens positions, incorrect colour profiles). Even though most projectors are equipped with automatic compensation for worn xenon bulbs, luminance discrepancies are very common.

Correcting audio level discrepancies would normally require a D-cinema engineer, whereas well-trained projectionists may be capable of adjusting the luminance levels for each macro by optimising the output current (xenon lamp percentage). If sufficient luminance cannot be achieved, a bulb replacement or a mechanical bulb alignment may be due.

Following these simple steps will be the projectionist's most important contribution in ensuring that the audience experiences a show the way that the filmmakers had intended.

REFERENCES AND SOURCES

LITERATURE:

Allen, Ioan (Dolby): *Matching the sound to the picture*, San Francisco, 1991.

Allen, John F.: *Powering up for digital*, Boxoffice Magazine, 1993.

Bert, Dr. Ir. Tom and Marescaux, Theodore, PhD (Barco): *4k resolution: more than meets the eye*, Kortrijk, 2011.

Comastri, S.A. – Echarri, R and Pfortner, T: *Correlation between visual acuity and pupil size*, Buenos Aires, 2004.

Digital Cinema Initiatives, LLC: *Digital Cinema System Specification, version 1.2*, Los Angeles, 2008.

Digital Cinema Initiatives, LLC: *Stereoscopic Digital Cinema Addendum, version 1.0*, Los Angeles, 2007.

Dolby Atmos Cinema Technical Guidelines, San Francisco, 2012.

Dolby Atmos Next-Generation Audio for Cinema, San Francisco, 2012.

Dolby Surround 7.1 Technical Paper, San Francisco, 2011.

Eastman Kodak Company: *A new dimension: a revolutionary change in digital cinema projection based on laser light sources*, Rochester, 2010.

Gardener, John W (US Departement of Health, Education and Welfare): *Monocular – Binocular: Visual Acuity of Adults, Unites States 1960–62*, Washington, 1968.

Harrah, Mark: *Digital Cinema Naming Convention version 3.8*, ISDCF, 2010.

ISDCF Doc 4: *16-Channel Audio Packaging Guide for Interop DCP*, ISDCF, 2011.

ISDCF Doc 8: *Theatre Key Retrieval (TKR) – A system for automated KDM delivery (v. 0.3)*, ISDCF, 2012.

Kiening, Dr Hans (ARRI): *4k+ Systems – Theory Basics for Motion Picture Imaging*, München, 2009.

Koebel, Alen (Christie): *Digital cinema projection: choosing the right technology*, Cypress, 2011.

Kuutti, Mikko: *The Pixel*, Helsinki, 2011.

Levison, Jeff: *IOSONO Explained, Resolution Magazine*, V11.3 April, 2012.

Mateos, Toni – Artigas, Alex and Lopéz, Vicente (Imm sound): *Immersive 3D sound for cinema*, Barcelona, 2011.

Mackenzie, Dana: *Wavelets – Seeing the Forest and the Trees*, Washington, DC, 2001.

Panavision 3D System Technical Overview, Panavision/DPVO Theatrical, LLC, 2011.

SMPTE ST 427:2009 Link Encryption for 1.5 Gb/s Serial Digital Interface

SMPTEST 428-1:2006 D-Cinema Distribution Master – Image Characteristics

SMPTE ST 428-2:2006 D-Cinema Distribution Master – Audio Characteristics

SMPTE ST 428-3:2006 D-Cinema Distribution Master Audio Channel Mapping and Channel Labeling

SMPTE ST 428-7:2010 D-Cinema Distribution Master – Subtitle

SMPTE ST 428-9:2008 D-Cinema Distribution Master – Image Pixel Structure Level 3 - Serial Digital Interface Signal Formatting

SMPTE ST 428-10:2008 D-Cinema Distribution Master – Closed Caption and Closed Subtitle

SMPTE ST 428-11:2009 Additional Frame Rates for D-Cinema

SMPTE ST 428-19:2010 D-Cinema Distribution Master – Additional Frame Rates Level AFR2 and Level AFR4 – Serial Digital Interface Signal Formatting

SMPTE ST 428-21:2011 Archive Frame Rates for D-Cinema

SMPTE ST 429-2:2011 D-Cinema Packaging – DCP Operational Constraints

SMPTE ST 429-3:2006 D-Cinema Packaging – Sound and Picture Track File

SMPTE ST 429-4:2006 D-Cinema Packaging – MXF JPEG 2000 Application

SMPTE ST 429-5:2009 D-Cinema Packaging – Timed Text Track File

SMPTE ST 429-6:2006 D-Cinema Packaging – MXF Track File Essence Encryption

SMPTE ST 429-7:2006 D-Cinema Packaging – Composition Playlist

SMPTE ST 429-8:2007 D-Cinema Packaging – Packing List

SMPTE ST 429-9:2007 D-Cinema Packaging – Asset Mapping and File Segmentation

Amendment 1:2010 to SMPTE ST 429-9:2007

SMPTE ST 429-10:2008 D-Cinema Packaging – Stereoscopic Picture Track File

SMPTE ST 429-12:2008 D-Cinema Packaging – Caption and Closed Subtitle

SMPTE ST 429-13:2009 D-Cinema Packaging – DCP Operational Constraints for Additional Frame Rates

SMPTE ST 430-1:2006 D-Cinema Operations – Key Delivery Message

Amendment 1:2009 to ST 430-1:2006

SMPTE ST 430-2:2006 D-Cinema Operations – Digital Certificate

SMPTE ST 430-3:2008 D-Cinema Operations – Generic Extra-Theater Message Format

SMPTE ST 430-4:2008 D-Cinema Operations – Log Record Format Specification

SMPTE ST 430-5:2011 D-Cinema Operations – Security Log Event Class and Constraints

SMPTE ST 430-6:2010 D-Cinema Operations – Auditorium Security Messages for Intra-Theater Communications

SMPTE ST 430-7:2008 D-Cinema Operations – Facility List Message

SMPTE ST 430-9:2008 D-Cinema Operations – Key Delivery Bundle

SMPTE ST 430-10:2010 D-Cinema Operations – Auxiliary Content Synchronization Protocol

SMPTE ST 430-11:2010 D-Cinema Operations – Auxiliary Resource Presentation List

SMPTE ST 431-1:2006 D-Cinema Quality – Screen Luminance Level, Chromaticity and Uniformity

SMPTE ST 433:2008 D-Cinema – XML Data Types

SMPTE RP 155-2004, Motion-Picture and Television — Reference Level for Digital Audio Systems

SMPTE RP 428-6:2009, D-Cinema Distribution Master — Digital Leader

SMPTE RP 431-2-2007, D-Cinema Quality — Reference Projector and Environment

Sony: *Does 4k really make a difference – 4k digital projection in the theatre environment*, Park Ridge, 2010.

Van Daele, Bert and Van Baelen, Wilfried (Auro Technologies): *Auro-3D Octopus Codec – Principles behind a revolutionary codec*, Mol, 2011.

Visual Acuity Measurement Standard, The International Council of Opthalmology, 1984.

Westheimer, Gerald: *Visual Acuity and Hyperacuity (Handbook of Optics, Chapter 4)*, Berkeley, 2010.

Winn, Barry – Whitaker, David – Elliot, David B. – Phillips, Nicholas J.: *Factors Affecting Light-Adapted Pupil Size in Normal Human Subjects*, Glasgow, 1993.

Wysotsky, Michael Z.:*Widescreen Cinema and Stereophonic Sound*, London, 1971.

WEB-SITES:

www.auro3d.com
www.barco.com
www.beyonddiscovery.org
www.christiedigital.com
www.civolution.com
www.datasatdigital.com
www.depthq.com
www.doremilabs.com
www.fiafnet.org
www.hps4000.com
www.immsound.com
www.iosono-sound.com
www.isdcf.com

www.kinoton.com
www.kodak.com
www.laserlightengines.com
www.lipainfo.org
www.masterimage3d.com
www.nec.com
www.reald.com
www.schott.com
www.smpte.org
www.sony.com
www.xpand.me

INDEX

Symbols
2k 11, 17, 19, 22, 23, 25, 26, 27, 28, 36, 37, 38, 39, 41, 48, 54, 61, 62, 65, 80, 114
3-D 11, 28, 32, 33, 46, 60, 61, 62, 66, 73, 75, 76, 77, 78, 79, 80, 81, 82, 83, 84, 85, 86, 87, 88, 89, 90, 93, 95, 96, 97, 107, 109, 110
4k 11, 12, 17, 19, 22, 24, 25, 26, 27, 28, 29, 36, 37, 38, 39, 41, 48, 49, 54, 55, 57, 60, 61, 62, 65, 66, 76, 80, 86, 101, 114, 116, 118
16mm 13
35mm 9, 10, 26, 31, 32, 36, 37, 41, 42, 44, 59, 76, 79, 85, 90, 100, 103, 104, 106, 109, 110
70mm 79, 100, 101, 104, 110

A
Active shutter systems 82
Afnor 86
Alternative content 110, 113
Amiran 72, 88
Archival Frame Rate 66
Atmos 11, 98, 99, 100, 101, 102, 106, 116
Audio 41, 45, 93, 94, 95, 99, 100, 116, 118
Audio sampling 93
Auro-3D 11, 42, 95, 96, 98, 102, 118

B
Barco 10, 22, 23, 24, 27, 59, 60, 61, 65, 97, 114, 116

C
Christie 10, 19, 22, 23, 27, 57, 59, 60, 61, 88, 114, 116
Chromaticity 14, 57, 117
CineLink 49, 65
CinemaScope 32, 37, 38, 39, 60, 61, 63, 89, 101
Circular polarisation 78
Civolution 49
CNC 86
CobraNet 104, 105, 106
Colour resolution 34

Colour space 33, 110
Colour triplet 83
Composition Play List 43
Content protection 13
Contrast 58
CPL 43, 44, 47, 48

D
Datasat 105, 106, 114
DCI 9, 10, 11, 12, 13, 31, 32, 33, 34, 35, 36, 37, 38, 39, 41, 42, 43, 44, 46, 48, 49, 51, 55, 56, 57, 58, 59, 60, 61, 87, 94, 95, 99
DCI compliance 12, 55
D-cinema 9
DCI specification 10, 12, 31, 34, 35, 36, 39, 41, 44, 46, 48, 94
DCP 10, 11, 12, 13, 31, 32, 34, 35, 43, 44, 45, 46, 47, 61, 64, 65, 70, 80, 87, 88, 94, 96, 106, 109, 110, 111, 112, 113, 116, 117
DCP ingest 111
DepthQ 78, 81, 87
Digital cinema 21, 116
Digital Cinema Initiatives 9, 116
Digital Cinema Package 11
D-ILA 51, 54
Dimensionalisation 76
Disposable glasses 79
DLP 11, 13, 19, 23, 27, 49, 52, 53, 54, 55, 56, 60, 61, 62, 65, 70, 79, 82, 85, 87, 88, 89, 90, 114
DLP projectors 27, 53, 54, 55, 56, 62, 65, 70, 79, 82, 114
DMD 11, 17, 36, 51, 53, 54, 62, 65, 70, 80, 85, 87
Dolby 11, 31, 44, 64, 65, 83, 84, 85, 87, 94, 95, 96, 98, 99, 100, 101, 103, 104, 105, 106, 115, 116
Dolby 3D 83, 84, 85, 87
Dolby Atmos 11, 98, 99, 100, 101, 106, 116
DVI 15, 70, 110

E
E-cinema 12, 13, 15, 56
EFIB 89
eSATA 66, 111
Excessive light 90
Extended surround 94

F
FFIB 89
FIAF 2, 5, 6, 7
FIPS 48
Frame rate 32

G
Ghostbusting 79
Grounding 71

H
HDCAM 13, 113
HD-SDI 11, 48, 70, 88
HFR 28, 32, 33, 49, 69, 87
Home cinema 12
Horizontal 24
Hyperacuity 21, 22, 118

I
Image containers 37
Imm sound 97, 98, 116
Infitec 83, 84, 85
In-Three 76
IOSONO 11, 96, 98, 101, 102, 103, 116

J
JPEG2000 11, 37, 39, 41

K
KDM 46, 47, 48, 109, 116
Key Delivery Message 46, 117
Kinoton 10, 61, 79
Kodak 58, 59, 61, 116

L
Laser projection 58, 88
LCD 13, 51, 52, 53, 54, 55, 79, 81
Linear polarisation 77, 79
LVDS 65

M
Maintenance 114
MasterImage 78, 81, 82, 87
Mirogard 72, 88
MTF 28, 61
MXF 44, 117

N
NEC 27, 59, 60, 61, 114
Network 71
NexGuard 49
NuVision 82, 83

O
Octopus codec 96

P
Panavision 3D 85, 86, 116
PCI Express 65
PEM 47
Pixel 17, 25, 26, 34, 116, 117
Polarisation 77, 82
Port hole 71
Power supply 63, 71
Projection 5, 6, 7, 9, 26, 28, 51, 114
Projector macros 110
Pyran-S-AR 72, 89

Q
QSC 106

R
RAID 64
Real-D 62, 78, 79, 80, 81, 82, 83, 84, 85, 86, 87
Resolution 18, 45, 116

S
Screen 42, 43, 73, 100, 117
Security 46, 117
Silver screen 82
Snellen chart 20

Sony 11, 12, 14, 19, 22, 23, 27, 31, 48, 49, 54, 55, 56, 57, 58, 59, 60, 61, 62, 65, 66, 79, 80, 84, 86, 88, 100, 104, 114, 118
Sound 73, 93, 99, 100, 117, 118
Stereo D 76
SXRD 11, 51, 54, 55, 56, 58, 61, 62, 70, 79, 80, 81, 82, 83, 84, 85, 86, 88, 114

T
Texas Instruments 11, 17, 36, 53, 61, 65
Theatre Management System 46
THX 24
TMS 46, 47, 66, 71, 109, 111, 112
Todd-AO 63, 100

U
UHP 11, 56, 57, 61
Ultra Panavision 70 63, 110
UUID 44

V
Ventilation 72
Visual acuity 19

W
Warranty 64
Wavelet 39
WFS 101, 102, 103
Widescreen 32, 118
Wireless router 71
Wrapping 44

X
Xenon lamps 57, 90
XML 44, 117

Y
Yamaha 104, 105, 106